• LOCOMOTIVE ⸱⸝ ᴛHE •

HIGHLAND RAILWAY

JOHN CHRISTOPHER & CAMPBELL McCUTCHEON

AMBERLEY

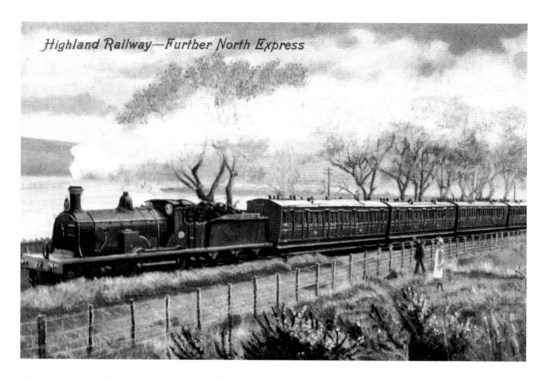

Highland Railway—Further North Express

This postcard, published *c.* 1905, looks like a scene from *The Railway Children*.

First published 2014

Amberley Publishing
The Hill, Stroud, Gloucestershire, GL5 4EP
www.amberley-books.com

Copyright © John Christopher & Campbell McCutcheon, 2014

The right of John Christopher & Campbell McCutcheon to be identified as the Authors of this work has been asserted in accordance with the Copyrights, Designs and Patents Act 1988.

ISBN 978 1 4456 3361 9 (print)
ISBN 978 1 4456 3373 2 (ebook)

British Library Cataloguing in Publication Data.
A catalogue record for this book is available from the British Library.

Typesetting by Amberley Publishing.
Printed in Great Britain.

Introduction

The Highland Railway was the most northerly of Britain's major railways, and one of its smallest. The company came into being in 1865 as the result of a merger of the region's smaller companies, most notably the Inverness & Aberdeen Junction Railway (I&AJR) and the Inverness & Perth Junction Railway (I&PJR). At its peak, before the grouping of the railways in 1923, the Highland Railway covered just under 500 miles of line. From Perth the mainline went north to Inverness, then via Dingwall it reached Thurso and Wick at its northern extreme. To the west it served Kyle of Lochalsh, and connecting with the Great North of Scotland Railway at Boat of Garten it extended eastwards to Elgin, Keith and Portessie. Southwards it connected with the Caledonian Railway at Stanley Junction.

The railways in this part of Scotland had their origins in the 'Railway Mania' years of the 1840s. The Great North of Scotland Railway had been formed in 1845 with the intention of building a line of 108 miles between Inverness and Aberdeen in order to link with the railways to the south. At the same time the Perth & Inverness Railway proposed a more direct route over the Grampians to Perth, while the Aberdeen, Banff & Elgin Railway wanted to follow a more coastal route to the Banffshire and Morayshire fishing ports. Only the Great North of Scotland Railway received Royal Assent, in 1846, but construction was delayed as Britain's railway bubble hit the buffers. It was 1854 before a line of only 39 miles to Huntly was opened, and an extension to Keith followed two years later. By this time the

Illustration from *The Engineer*: HR 89, *Sir George*, a Jones 4-4-0 D class Strath built in 1892.

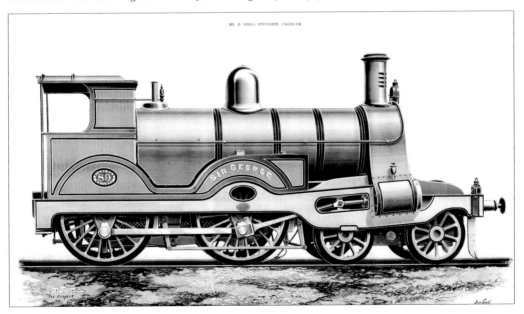

Inverness & Nairn Railway had been given permission for a line between Inverness and Nairn, with a short branch to Inverness harbour, and this opened in November 1855. The next decade saw a miss-mash of projects involving a number of players including the IAJR, the Great North of Scotland Railway, the Inverness & Ross-shire Railway (I&RR), the Morayshire Railway and the Inverness & Perth Junction Railway (I&PJR). Gradually the connections were made, but the route south via Aberdeen involved changes between railway stations, by horse-drawn omnibus, causing considerable inconvenience to travelers. More direct routes were proposed by the rival companies and in 1865 the I&AJR was merged with the I&PJR and the new joint venture became the Highland Railway came into existence on 29 of June. At that time the railway owned 242 miles of line.

The Highland Railway's first General Manager was Andrew Dougall, who had been founding General Manager of both companies. Meanwhile, William Barclay, who had been locomotive supervisor to both of the constituent railways, resigned his post and the Highland Railway appointed its first locomotive supervisor, William Stroudley.

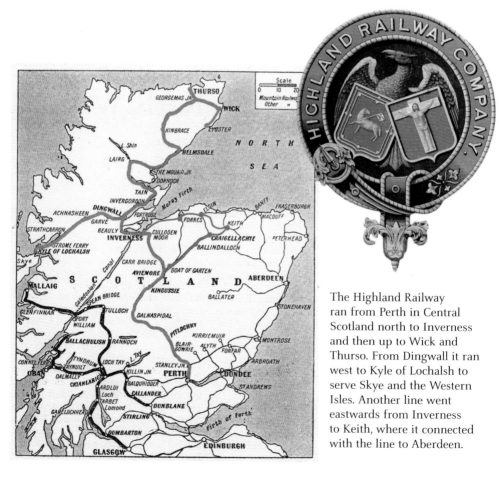

The Highland Railway ran from Perth in Central Scotland north to Inverness and then up to Wick and Thurso. From Dingwall it ran west to Kyle of Lochalsh to serve Skye and the Western Isles. Another line went eastwards from Inverness to Keith, where it connected with the line to Aberdeen.

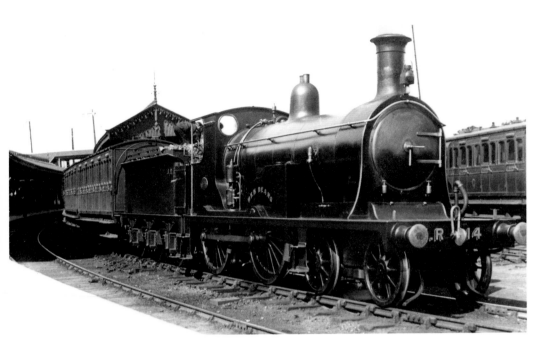

Above: Drummond 4-4-0 HR 14, *Ben Dearg,* heading a passenger train at Forres station.

William Stroudley 1855–69

Stroudley's tenure in the role of locomotive supervisor was relatively short-lived. The company had inherited a number of locomotives and, significantly, the locomotive works at Lochgorm, Inverness, which had been built by the Inverness & Nairn Railway. Only one new design, an 0-6-0 saddle tank, emerged from Lochgorm, and three of the 'Stroudley tanks' were built between 1869 and 1874.

David Jones 1870–96

Stroudley's successor was David Jones, who produced a number of notable classes: The 4-4-0 F class 'Dukes', the 2-4-0 H class 'Raigmores', the 4-4-0T O class 'Jones tank', the 4-4-0 L class and E class known as 'Skye Bogies' and 'Clyde Bogies', the 0-4-0 13 class saddle tanks of which only one example was built, the 4-4-0 D class 'Straths', the 4-6-0 tanks intended for Uruguay originally and hence known as the 'Yankee tanks', the I class of 'Big Goods' or 'Jones Goods' – the first 4-6-0s to operate on any British railway – the B class 4-4-0 'Lochs' of which eighteen were built. In addition to Lochgorm's output, several outside locomotive builders were used; Dübs & Co. and the Clyde Locomotive Co., Neilson & Co., all three being in Glasgow, as well as Sharp, Stewart & Co. in Manchester, the North British Locomotive Company (a 1903 merger of three loco companies) and Kitson & Co. of Leeds. In addition the company had also acquired a solitary T class 2-4-0 tank from the Duke of Sutherland's Railway in 1895. Jones retired in 1896 after being severely scalded during testing of a Big Goods engine.

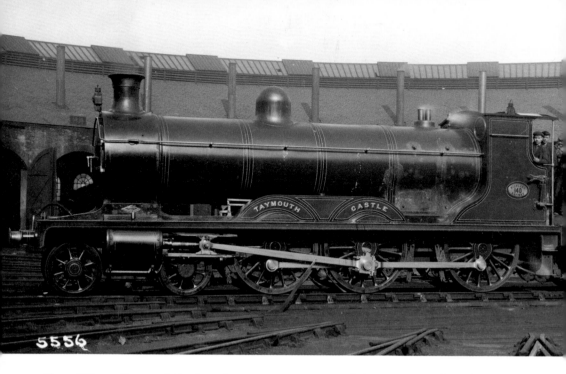

5556

Above: HR 140, *Taymouth Castle,* at Inverness – *see page 55. Below:* A crane is brought in to assist with the installation of a new turntable at the Inverness Round House, *c.* 1922.

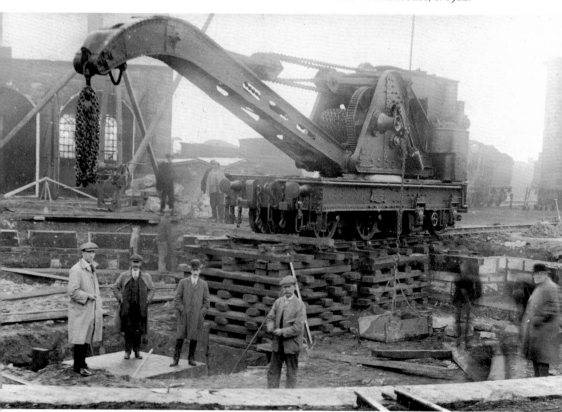

Peter Drummond 1896–1912

The younger brother of the noted locomotive designer and builder Duguld Drummond, Peter Drummond produced seventy-two locomotives, including several new designs, for the Highland Railway: The 4-4-0 C class 'Small Bens', the K class 0-6-0 'Barneys', the A class 4-6-0 Castles, the V and W class sadlle tanks, his 4-4-0 U class known as the 'Large Bens' and the X class 'medium goods' 0-6-4 tanks.

Frederick George Smith 1912–15

Smith's time at the Highland Railway was cut short by a dispute over his design for the 4-6-0 'River' class. Six were built by Hawthorn Leslie, but they were considered by the company's civil engineer to be too heavy to operate on the line. They were sold to the Caledonian Railway, but were to reappear in LMS colours on the Highland's rails.

Christopher Cumming 1915–22

The last of the pre-grouping locomotive supervisors of the Highland Railway, Cummings designed one class of 4-4-0 types, the 'Snaigow' class of which only two were built, and two types of 4-6-0s, the Clan Goods and the Clans.

When the Highland Railway was absorbed within the London, Midland & Scottish Railway (LMS) in 1923 its remaining locomotives were handed over to the new company. A good number remained in service with the LMS and some even continued into the British railways era with several of the Clan Goods and Clans, HR 76, 79, 80, 81 and 56, not withdrawn until the 1950s.

Below: HR 57B, LMS 16119, one of Stroudley's 0-6-0 tanks, built 1872.

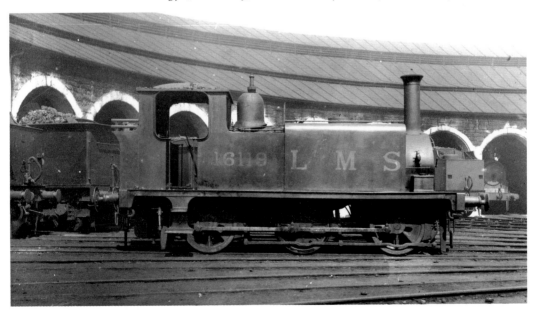

About this book

This new selection of original Highland Railway photographs and postcards comes from the J. & C. McCutcheon Collection. They are arranged in approximate chronological order based on the commencement of each type. As anyone familiar with the Highland Railway will know, the company habitually transferred and reused engine names and numbers. In some cases names were moved on up to five occasions, and it was not unknown for numbers to be changed, only to revert back at a later date. The original HR numbers have been used in the first instance. Every effort has been made to verify the information, and if there are any errors we welcome any input from readers, which will be incorporated into the future editions.

Locomotives of the Highland Railway is the third volume in a series of books on the locomotives of the pre-grouping railways. The others titles published so far are:

1: *Locomotives of the Great Northern Railway*
2: *Locomotives of the London Brighton & South Coast Railway*
4. *Locomotives of the North Eastern Railway.*

The Locomotives

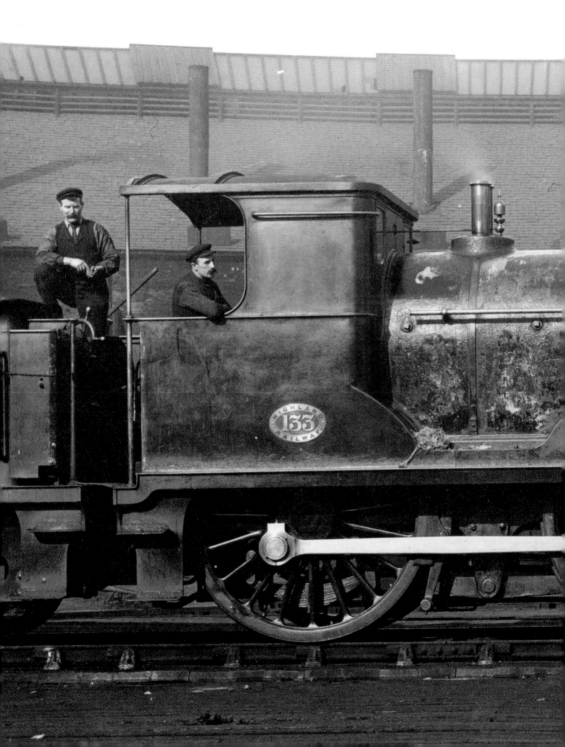

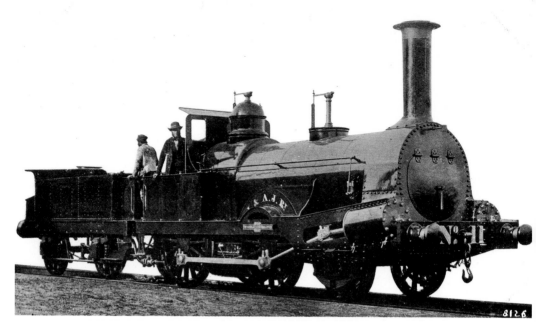

Transferred locos

The Highland Railway acquired a number of lcomotives brought in from other companies. *Above:* The Inverness & Aberdeen Junction Railway's 2-4-0, *Stafford*, was built by Hawthorn's in Leith in 1850 and transferred to the newly-formed HR in 1865. Rebuilt in 1878 it was renamed *Skibo*. Withdrawn in 1897. *Below:* HR 118 was an 0-6-0 tank built in 1870, by Kitson & Co. of Leeds, for the Duke of Sunderland's private line which connected with the HR. The company acquired the loco in 1895 and after a rebuild it was renamed as *Gordon Castle*. Renumbered HR 118A in 1913, withdrawn 1923. Note the dog on the footplate.

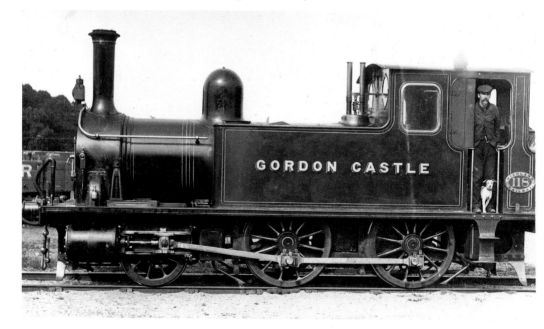

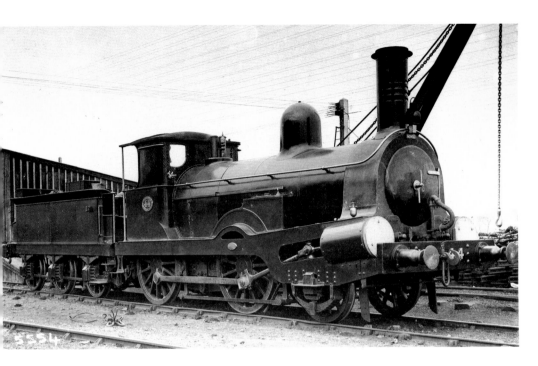

I&AJR '36' class

Two of ten '36' class 2-4-0 locomotives built by Sharp, Stewart & Co. for the Inverness & Aberdeen Junction Railway in 1864. Numbered 36–45 these small to medium goods locos were rebuilt between 1876 and 1889 with larger driving wheels and bigger cylinders. The '36' class were very similar in design to the Glenbarries – *see overleaf. Above* is HR 44, *Brodie*, which was withdrawn in 1912 after almost forty years of service. *Below,* HR 38, *Kincraig,* withdrawn in 1902.

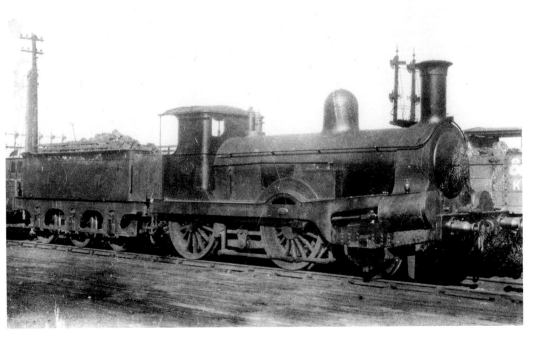

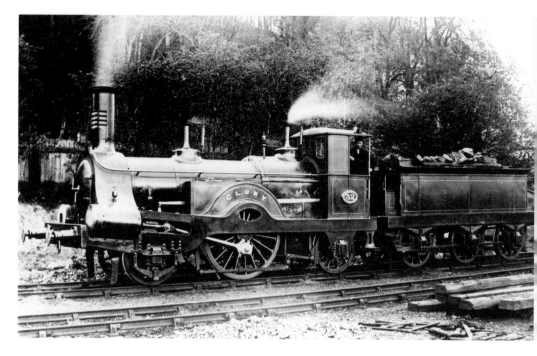

I&AJR Glenbarry class

Numbered 28–35 and 46–55, the eighteen Glenbarries built for the I&AJR in 1863/4 were 2-2-2 locos built by two companies, Hawthorns and Neilson & Co. Designed by William Barclay, they were intended for passenger services. *Above,* HR 32 was originally named *Sutherland,* but was renamed as *Cluny* in 1874. Withdrawn 1898. Cluny Castle is in Aberdeenshire. *Below:* HR 31, *Princess,* was named in honour of Princess Alexandra of Denmark who married Edward Prince of Wales, the future King Edward VII, in 1863. HR 31 was withdrawn from service in 1898.

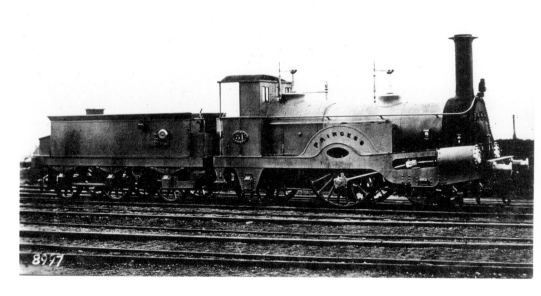

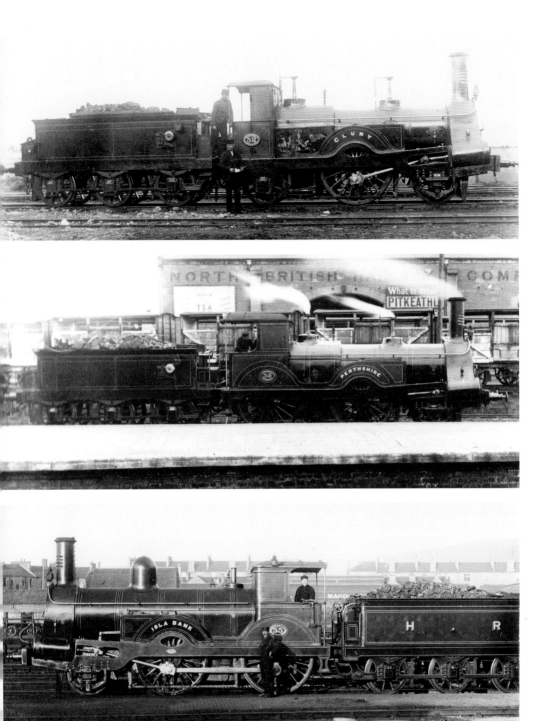

Three more Glenbarries – *from the top:* Another view of HR 32, *Cluny. Middle:* HR 34, *Perthshire,* pulling into Perth station. Originally named *Seafield,* it was renamed in 1889 and was the second loco to bear the name. *Bottom:* HR 35, *Isla Bank,* was originally named *Kingsmill.* Renumbered as HR 35A in 1911, it was the longest-lived of the class and remained in service until shortly after the grouping of Britain's railways in 1923.

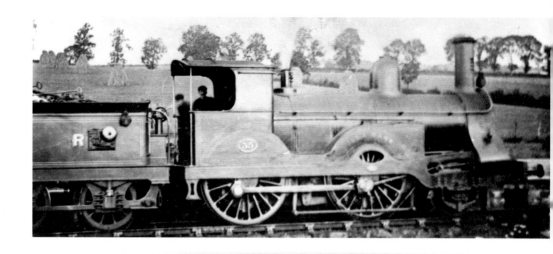

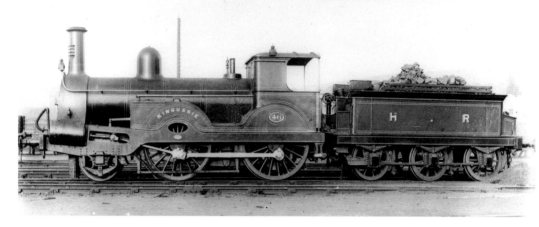

Top: HR35, *Glenbarry,* and HR 46, *Kingussie.* As was common practice the names were reused and HR 46 was *Clachnacuddin* before it became the second *Kingussie* in 1883. Withdrawn 1906. *Below:* HR 51, *Blair-Atholl.* This had been previously called *Caithness.* Withdrawn 1893.

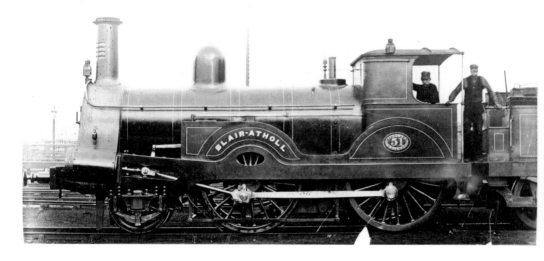

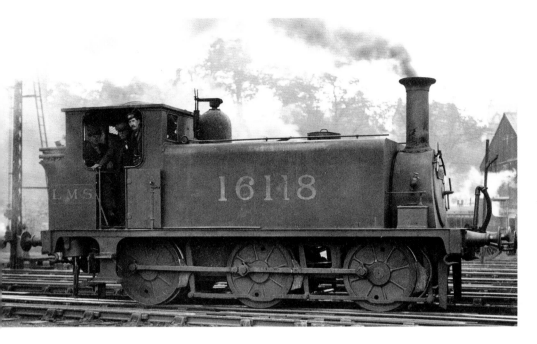

The Lochgorm tanks – 56 class

The first locomotives to emerge from the company's Lochgorm works were three 0-6-0 saddletanks which are sometimes given their class name after the first, HR 56, *above*. Built in 1869, it was rebuilt in 1896. Originally named as *Balnain*, renamed *Dornach* in 1902, it was numbered variously as 56, 56A and 56B. It is shown wearing its LMS No. 16118. HR 57, *Lochgorm*, was the second of the class. Built in 1897, it became LMS 16119 and was not withdrawn until 1932, making it the longest serving. The third was HR 16, *St Martins*, later renamed *Fort George*, renumbered 49 and 49A, and by the LMS as 16383. Designed by William Stroudley, these locos are considered to be the forerunners of his 'Terrier' class for the London Brighton & South Coast Railway.

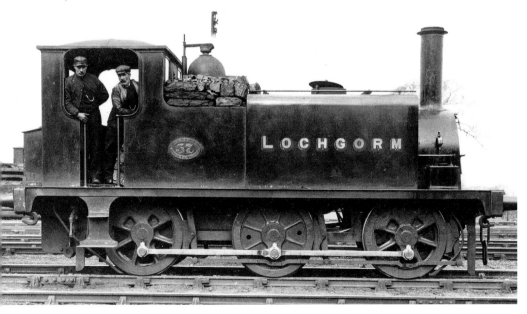

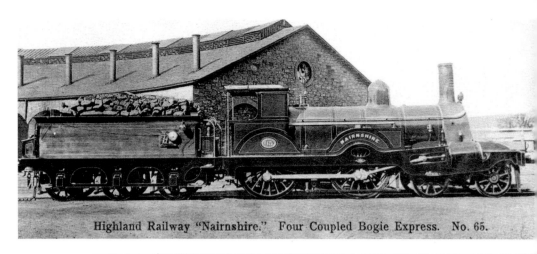

Highland Railway "Nairnshire." Four-Coupled Bogie Express. No. 65.

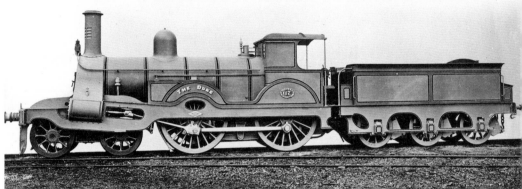

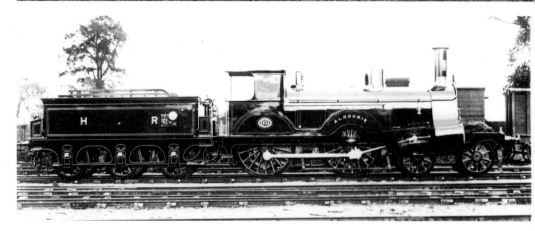

Lochgorm Bogies – F Duke class

David Jones followed Stroudley as locomotive superintendent in 1870. The first locos constructed to his design were the 4-4-0 class intended for express passenger services. Between 1874 and 1888 a total of seventeen Dukes were built; ten by Dübs of Glasgow and seven at the the Lochgorm works, and they were known as 'Lochgorm Bogies'. *From the top:* The first of the class was HR 65, *Nairnshire*, which was later renamed *Dalraddy* and withdrawn in 1909. HR 67, *The Duke*, is shown in its workshop grey. Renamed as *Cromatie* in 1877 it was withdrawn in 1923. HR 69, *Aldourie*, had been built in 1874 as *Sir James*. Rebuilt twice it was withdrawn and sold in 1909.

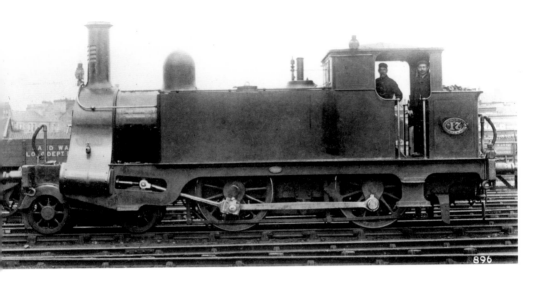

O class

Three tanks were built between 1878 and 1879 for shunting duties. They were originally of 2-4-0 configuration, but were soon rebuilt as 4-4-0s. *Above:* HR 17 was actually the third to be built. Named *Breadalbane*, later renamed *Aberfeldy*, it was renumbered HR 50 in 1901, and again as 50B in 1920. LMS No. 15012 was withdrawn in 1929. *Below:* HR 58 was the first of this class in 1878, it was renumbered 58A and 58B, before becoming 15011 under the LMS. Withdrawn 1928.

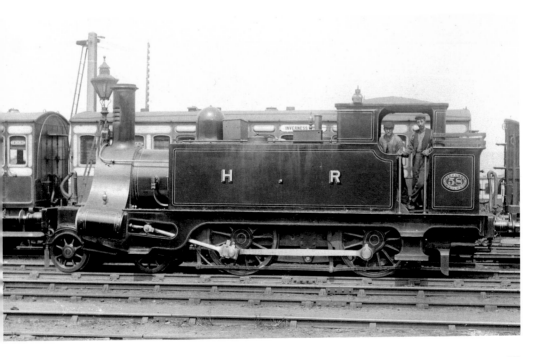

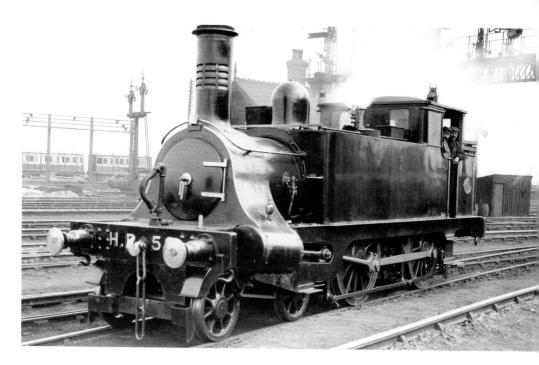

Above: HR 58 in remarkably pristine condition. All three of the O class were still in service at the time of the grouping of the railways and they served as shunters with the LMS. *Below:* HR 59 bearing its *Highlander* name, which was removed in 1900 without a replacement. HR 59 was renumbered 59A in 1912, and 59B in 1920. Its LMS number was 15010 and this was the last of the class to be withdrawn, in 1933. In this photograph it is shown in its as-built configuration of 2-4-0. The O class were rebuilt as 4-4-0s because of problems with the single leading axle.

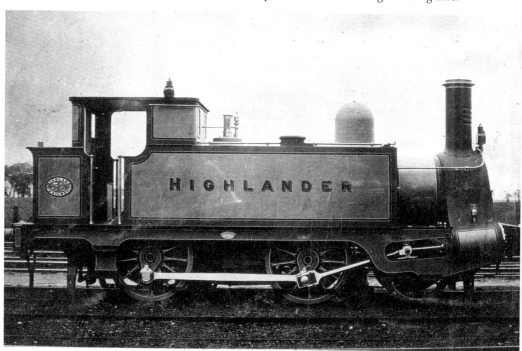

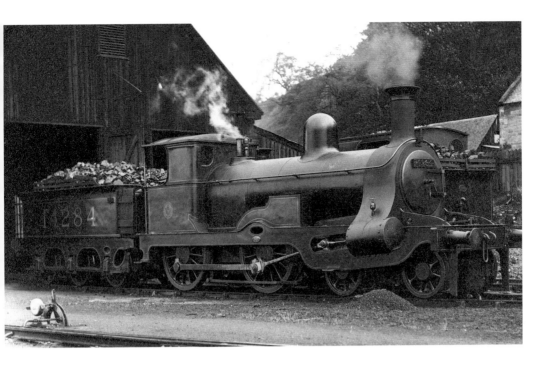

L class Skye Bogies

Nine of the 4-4-0 'Skye Bogies' were built at Lochgorm between 1882 and 1901 and got their class name as they were intended for the Dingwall and Skye line. *Above:* HR 7 was completed in 1898. It was renumbered 34 the following year and was operated by the LMS as 14284 until withdrawal in 1930. *Below:* HR 32 on the turntable in front of the shed at Inverness. Built as HR 5 in 1897 it had been renumbered in 1899. This engine went on to serve with the LMS as No. 14282 and was withdrawn in 1929. None of the class was named.

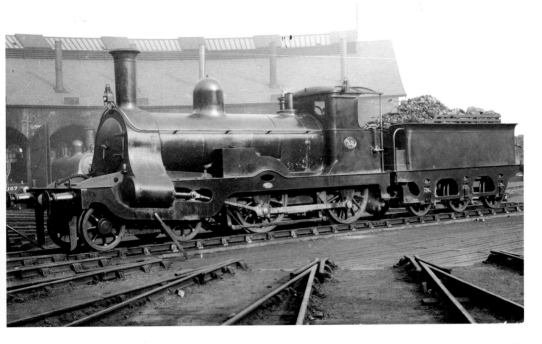

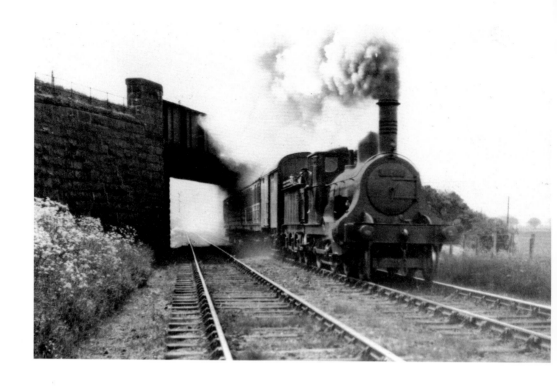

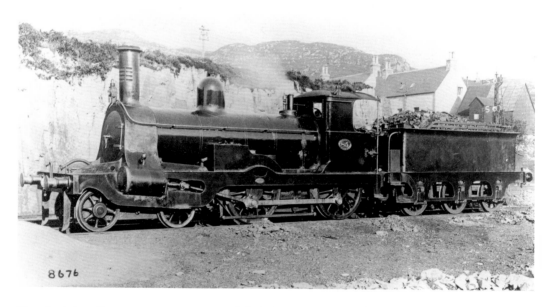

8676

Top: An interesting contemporary postcard depicting HR 48 at work. This crude tinting effect was a common method of creating colour photographic cards, but the colours bear no relation to the actual company livery. HR 48 was the last of the mixed-traffic Skye Bogies when built in 1901. Its LMS number was 14285 and this engine was withdrawn in 1929. *Lower image,* HR 85 at Kyle. Built in 1892, it was renumbered as 85A in 1919, but the only one of this class not to be allocated an LMS number as it was withdrawn in 1923.

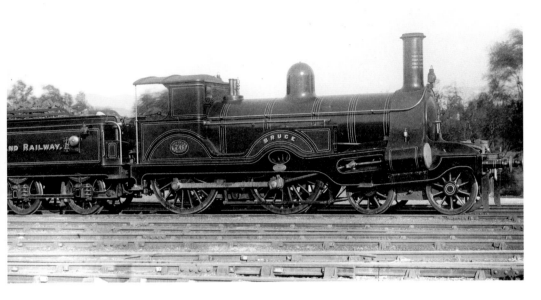

E class – Clyde Bogie

In 1886 eight of these 4-4-0 engines were built for the Highland Railway by the Clyde Locomotive Company in Glasgow. Developed by Jones from the previous F class, they were originally called the Bruce class, although unofficially know as 'Clyde Bogies'. *Above:* HR 76, *Bruce.* It was common practice for names to be transferred from engine to engine and HR 76 was the fifth to bear this particular name. It was displayed at the International Exhibition of Industry, Science and Art held in Edinburgh in 1886. Renumbered 76A in 1917, it was withdrawn in 1923. *Below:* HR 81, *Colville,* photographed at Inverness. Renumbered 81A in 1917, withdrawn in 1923. Note the bell on the side of the tender, just behind the cab.

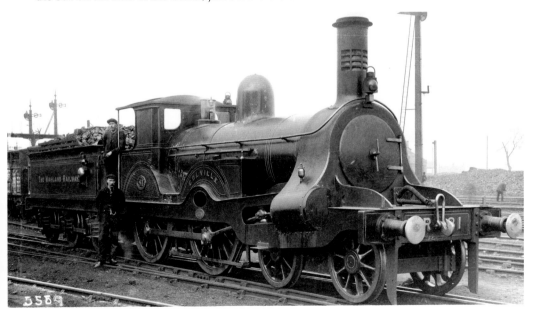

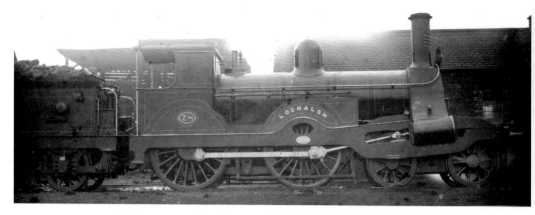

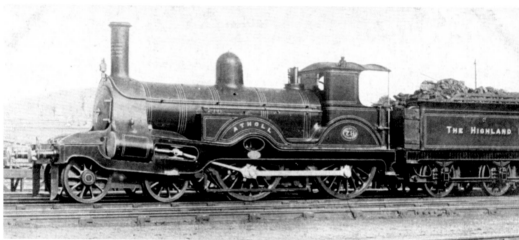

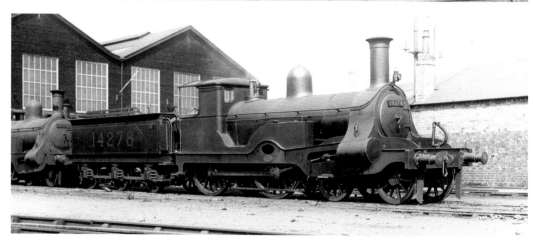

Three more Clyde Bogies, *from the top:* HR 78, *Lochalsh,* which was renumbered as 78A in 1917, withdrawn 1923. *Middle:* HR 79, *Atholl,* renumbered as 79A and also withdrawn in 1923. *Bottom:* HR 82, *Fife,* renamed as *Durn* in 1900 and renumbered as 82A in 1917. Of the E class locos handed over to the LMS in September 1923, five had been withdrawn. 76A and 81A were withdrawn in 1924, leaving 82A as the only one to receive an LMS number, 14278. It was withdrawn in 1930.

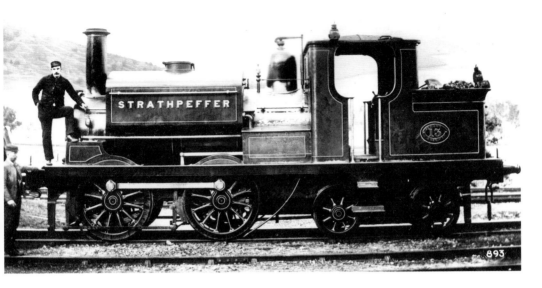

HR13 Strathpeffer

HR 13 was built in 1890 to replace the aging *Belladrum* class HR 12, a 2-2-2 tank called *Strathpeffer*. Confusingly the 0-4-4 HR 13 had the same name, although renumbered as 53 and 53a, and renamed as *Lybster* in 1903 when it went to the Wick to Lybster line. As plain 15050 it continued in service until 1929.

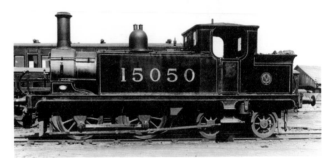

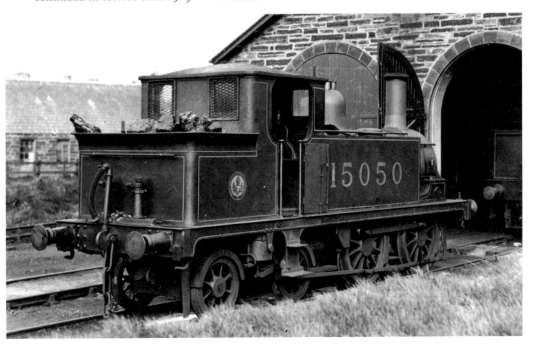

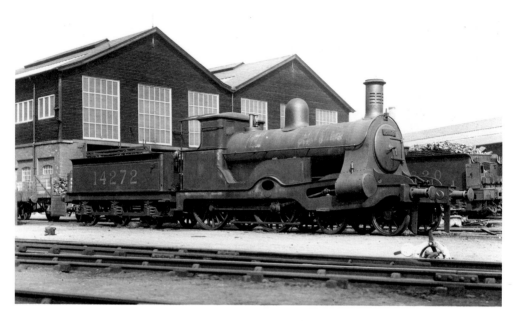

Strath class

A class of twelve 4-4-0 passenger engines built to a David Jones design by Neilson Reid & Co., Glasgow, in 1892. The Straths were vitually identical to the E Clyde Bogies apart from having larger diameter boilers. *Above:* HR 92, *Strathdearn*, later renamed *Glendean* and variously renumbered 92A and 92 at different times. It became No. 14272 under the LMS and continued in service until 1930. *Below:* HR 95, *Strathcarron* which became LMS 14274 until withdrawal in 1930. *Opposite, from the top:* HR 93, *Strathnairn*, renumbered 93a and withdrawn 1923. *Middle:* Last of the class, HR 100, *Glenbruar*, at Achnasheen station. LMS 14276, withdrawn 1930. *Bottom:* HR 94, *Strathay*, at Dingwall. LMS number 14273 never applied, withdrawn 1924.

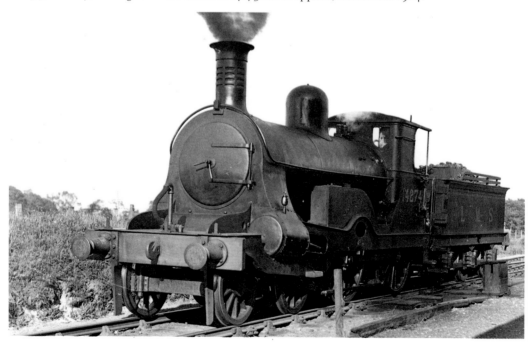

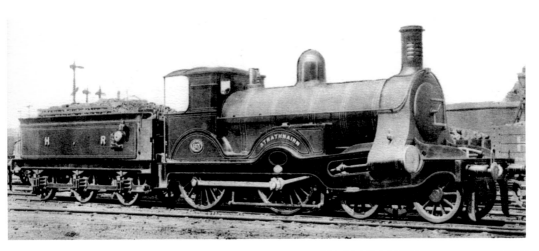

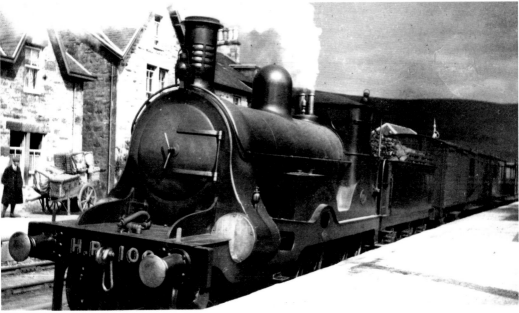

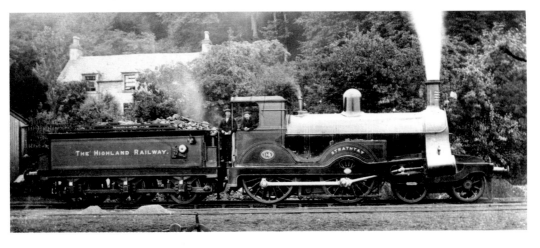

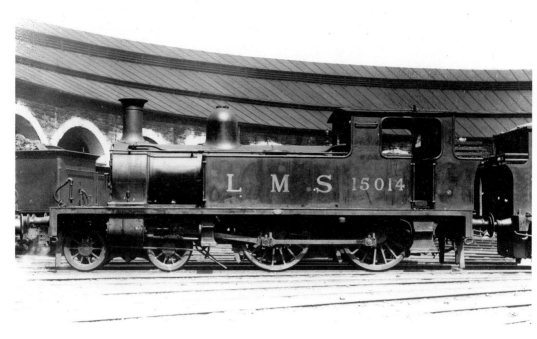

The 'Yankee Tanks'

Two 4-4-0 tanks which were built by Dübs & Co., of Glasgow, in 1892 for the Uruguay Great Eastern Railway, but never delivered, became the Highland Railway's HR 101 and 102. A further three of the same design were ordered the following year. *Above:* HR 102 at Inverness showing its LMS number, 15014. *Below:* HR 101, which was renumbered 101A and back to 101 before becoming LMS 15013. Withdrawn in 1934, this photo appears to show the engine at the breakers.

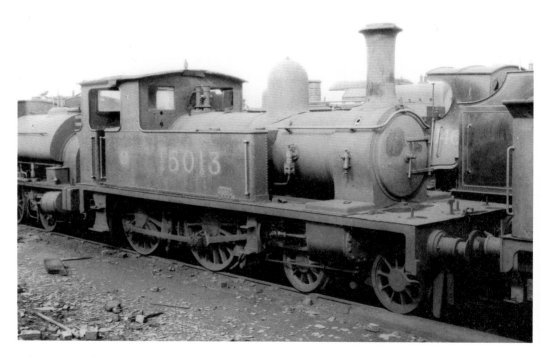

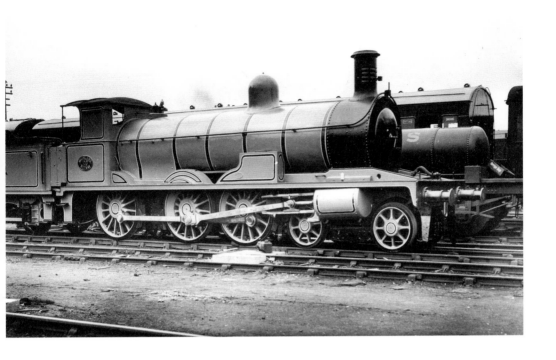

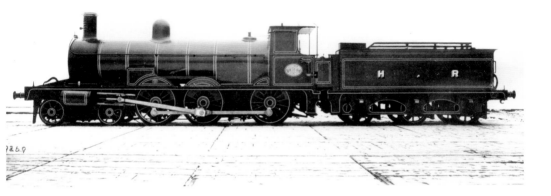

Jones Goods

The long, slender profile of the big Jones Goods, which was the first class in Britain to feature a 4-6-0 wheel arrangement. Originally known as the Big Goods class, fifteen were built in 1894 by Sharp, Stewart & Co., of Manchester. At the time they were the most powerful locomotives in the country and although intended for goods services they were frequently called upon to work passenger trains. During testing of one of the engine an accident led to David Jones being severely scalded on one of his legs. It left him permanently affected and he retired as the HR's locomotive superintendent in 1896 due to ill health. Despite this, the class was highly successful and all fifteen passed into LMS ownership.

Above: Two views of HR 103, which was numbered as 17916 by the LMS. Withdrawn in 1934, it was restored to its original condition in Highland green livery by the LMS and in 1959 it was returned to full working order by British Railways. HR 103 is the only survivng Highland Railway locomotive and is now displayed in pride of place at the Museum of Transport in Glasgow.

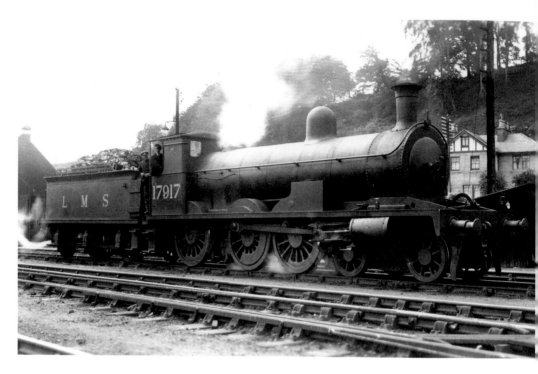

More Jones Goods. *Above:* HR 104 wearing LMS number 17917. It continued in service until 1939. *Below:* Another colour tinted postcard, this time showing HR 105 hauling a mixed goods train. As LMS 17918, it was withdrawn in 1933.

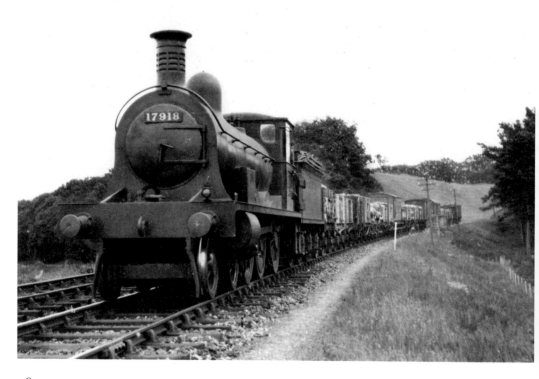

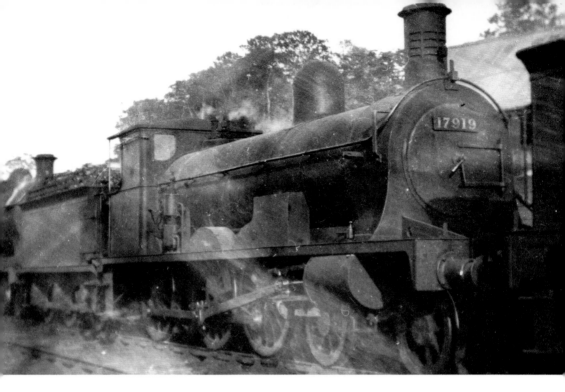

Above: HR 106 in a line up of engines. It became 17919 with the LMS and was retired in 1934.
Below: HR 107 in post-grouping livery as LMS No. 17920. It continued in service until 1937.

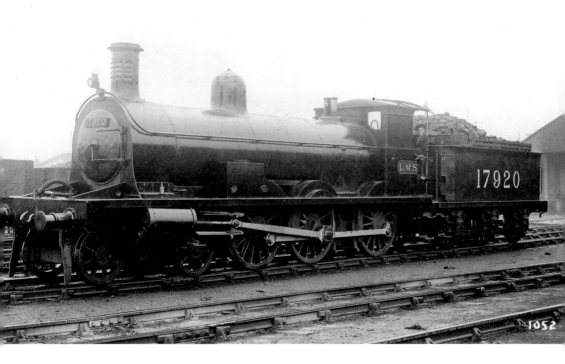

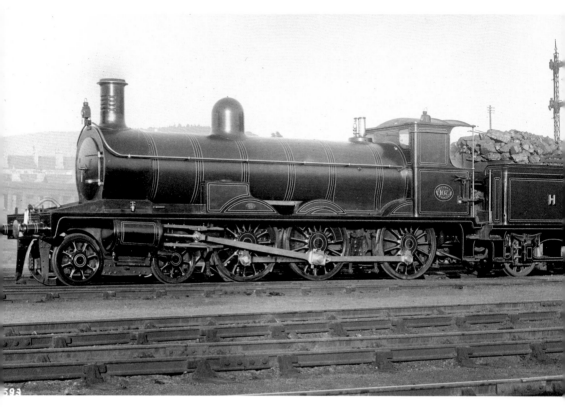

Above: Another view of HR 107, this time in its Highland Railway colours. *Below:* HR 111, which became LMS 17924. It is shown in its LMS days standing in front of LMS 13101, which is a Hughes Crab 2-6-0 built at Crewe in 1928.

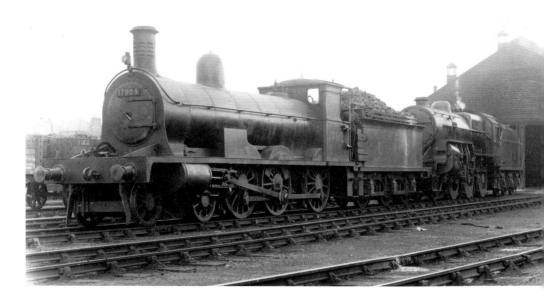

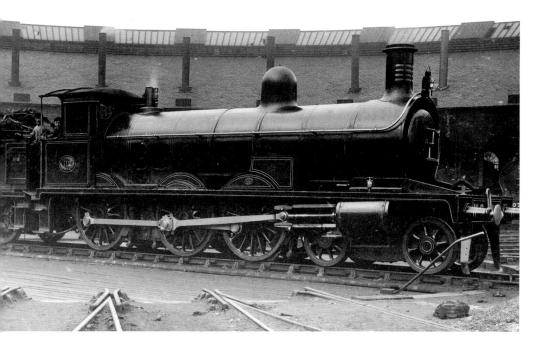

Above: HR 112 on the turntable at Inverness. This engine became LMS 17925 and had a long career, not being withdrawn until 1940. *Below:* Postcard of HR 113, *c.* 1905. Numbered 17926 by the LMS and withdrawn in 1939.

Highland Railway Bogie Goods Locomotive. No. 113.

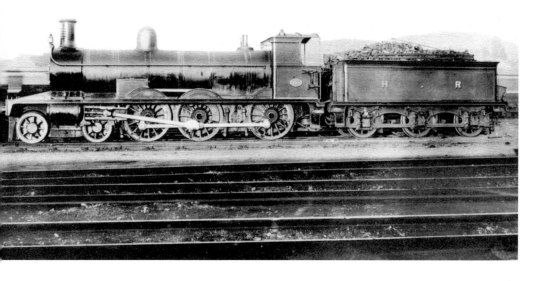

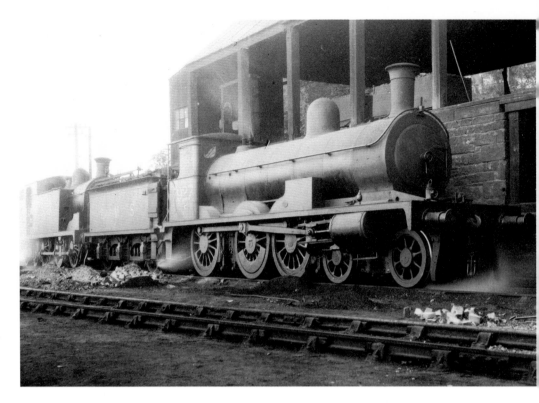

Above: HR 114, Jones Goods. This became LMS 17927 after the grouping of Britain's railways, and was withdrawn in 1936. *Below:* HR 117, the last of the class. As LMS 17930 it was withdrawn from service in 1939. *Opposite page:* Two final views of HR 117, in LMS livery, *top*, and in HR colours.

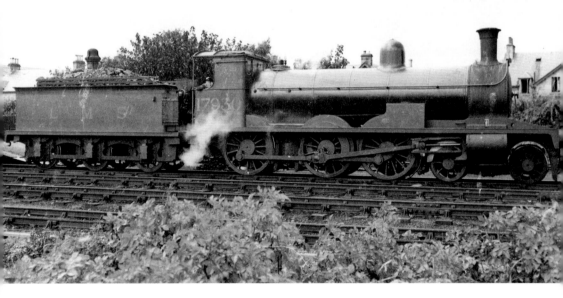

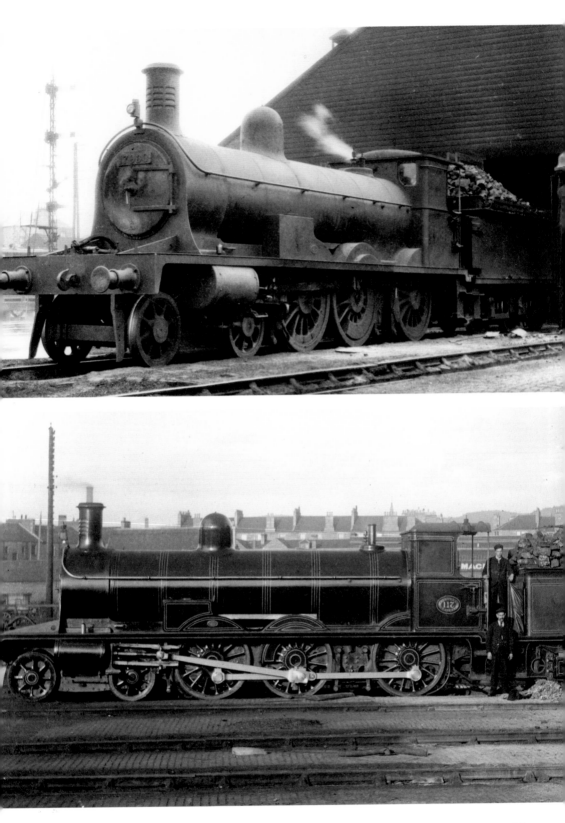

33

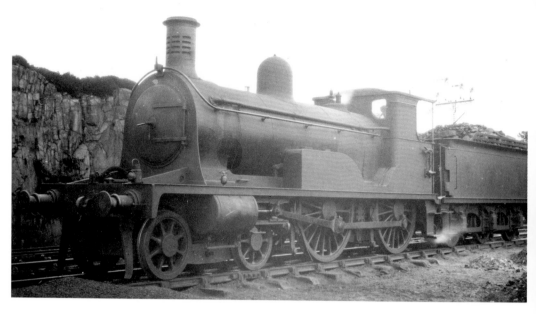

B or Loch class

One of the largest groups of Highland Railway locos, eighteen of the B class, otherwise known as the Loch class, were built. Fifteen by Dübs & Co., Glasgow, and three by Dub's successor, the North British Locomotive Company. These large 4-4-0s, designed by David Jones, were also long-lived as they were introduced in 1896 and the final three were built in 1917. *Above:* HR 70, *Loch Ashie*, which became LMS 14394 until withdrawal in 1936. *Below:* The former HR 72, *Loch Ruthven*, as LMS 14396. Withdrawn 1934.

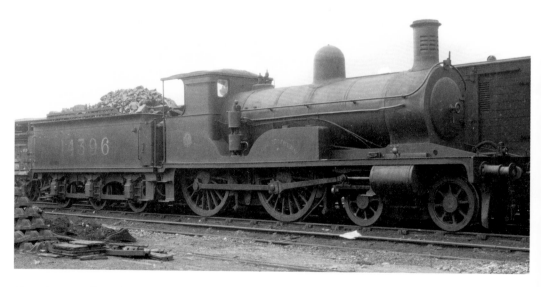

Opposite page, from the top: HR 72, *Loch Ruthven*, LMS 14396, at Lochgorm works for scrapping. HR 119, *Loch Insh*, first of the class. LMS number 14379. HR 119 is also shown, *bottom*, in 1947 at Aviemore. Not scrapped until 1948, it was one of the few Highland locos to be allocated a British Railways number, 54379, although never applied.

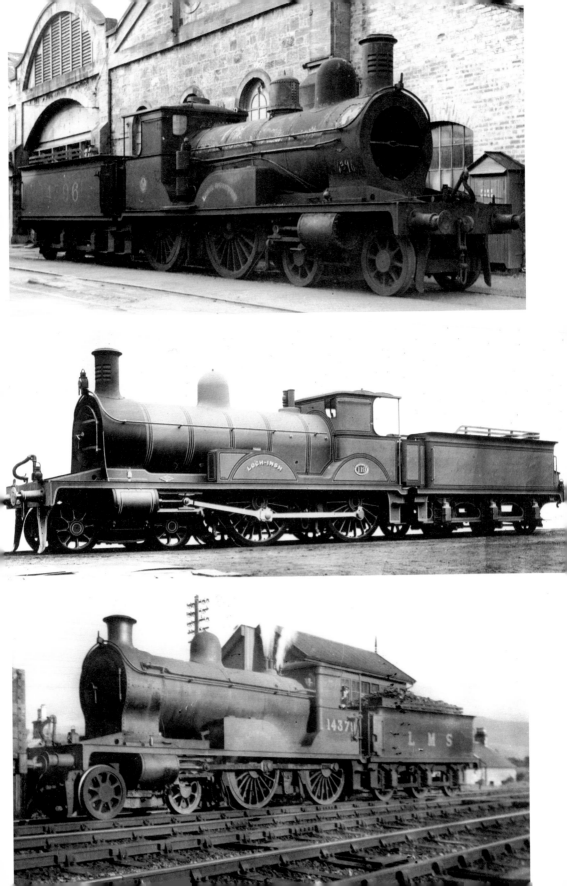

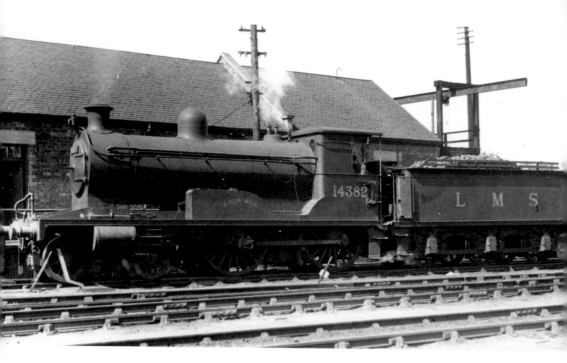

Above and below: Loch Moy, HR 122. LMS number 14382, and withdrawn in 1940. Note that as this photo shows, the Lochs continued to carry their names in the post-grouping era.

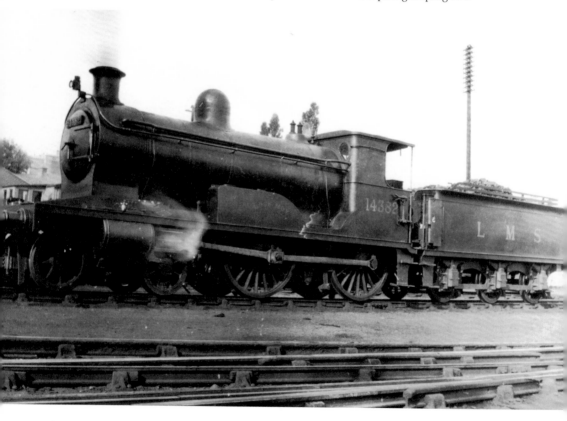

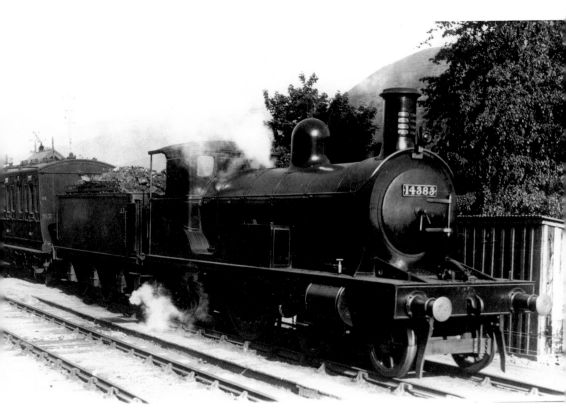

Two views of HR 123 *Loch an Dorb. Above,* at Altnabreach station, which is said to be the eighth least used station in Britain. HR 123 was renumbered by the LMS as 14383, and was withdrawn relatively early in 1934.

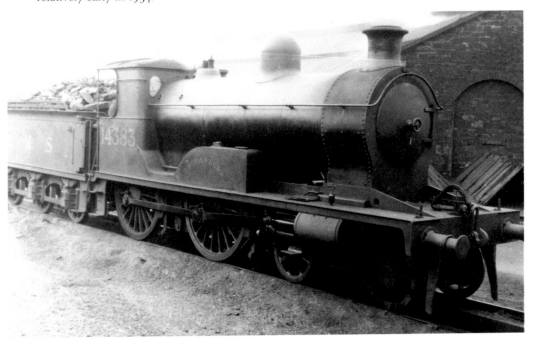

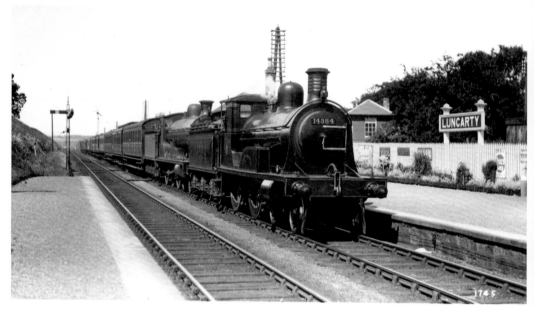

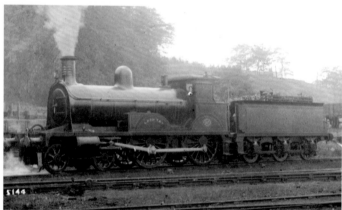

Above: HR 124, *Loch Laggan,* at Luncarty. LMS 14384, withdrawn 1938.
Left: HR 125, *Loch Tay,* later to become LMS 14385. It was the last of the Lochs to be withdrawn, in 1950.
Below: HR 126, *Loch Tummel.* LMS number 14386 and withdrawn in 1938.

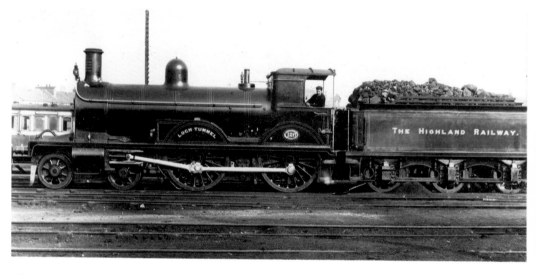

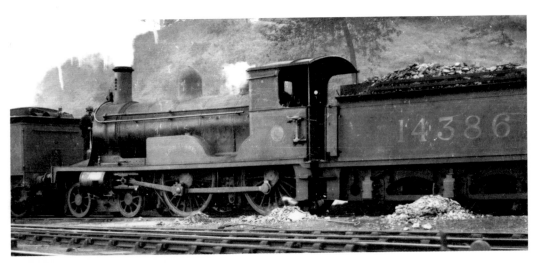

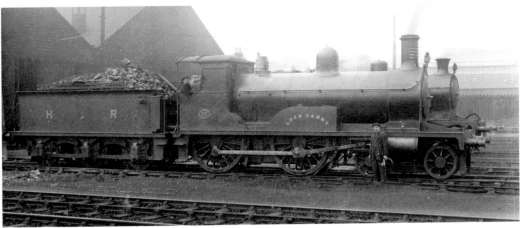

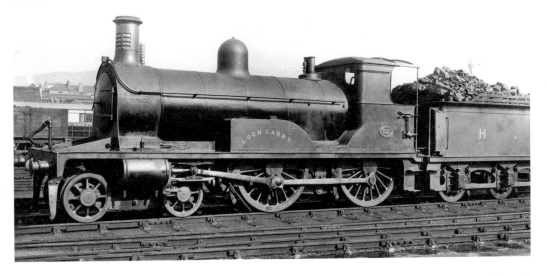

Top: HR 126, *Loch Tummel*, below the Barracks at Inverness. *Middle and bottom:* Two views of HR 127, *Loch Garry*, LMS 14387, withdrawn 1930.

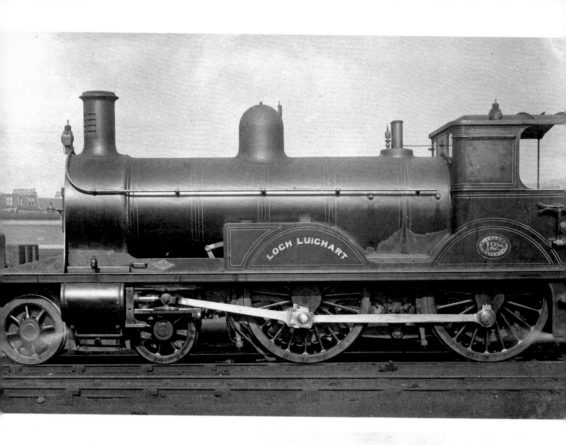

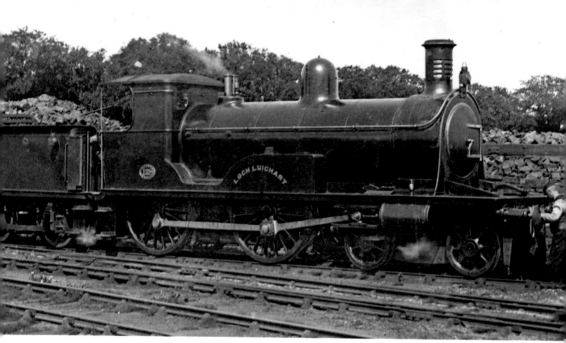

Two views of HR 128, *Loch Luichart*. LMS number 14388, this engine was withdrawn in 1930.

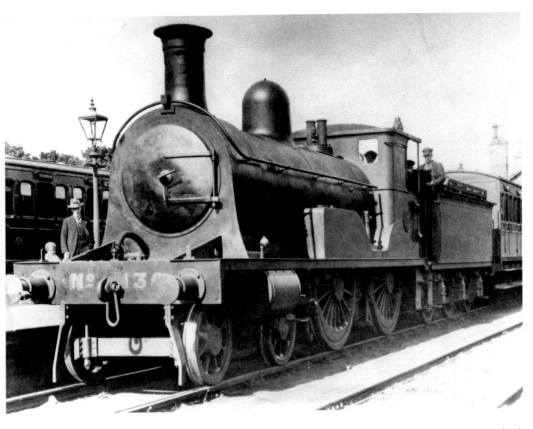

Above: HR 130, *Loch Fannich,* later to become LMS 14390, as shown *below* at the Inverness shed. Withdrawn from service in 1937.

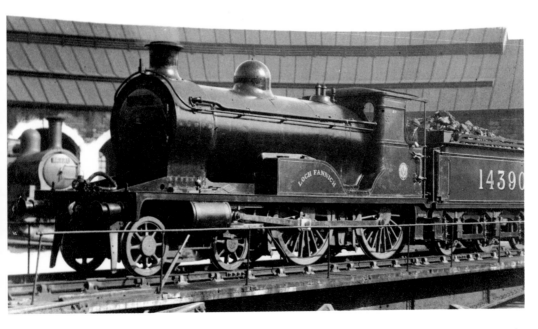

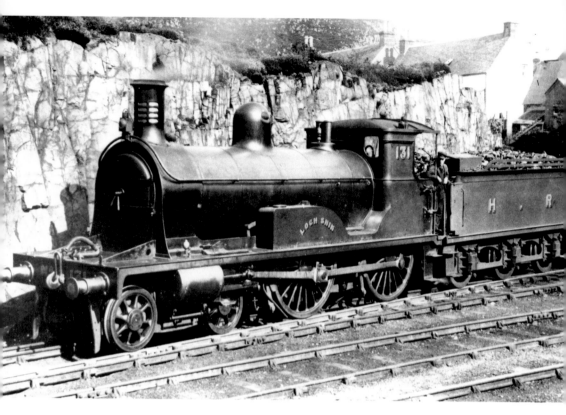

HR 131, *Loch Shin*. LMS number 14391, withdrawn during the Second World War in 1941.

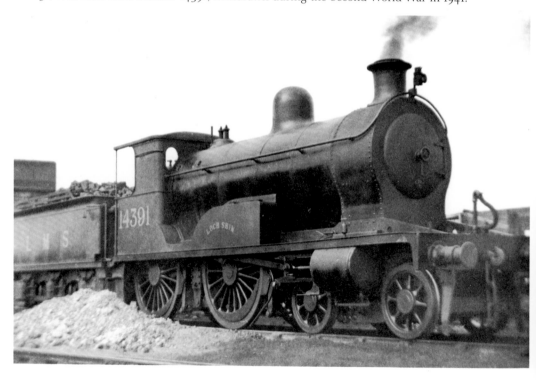

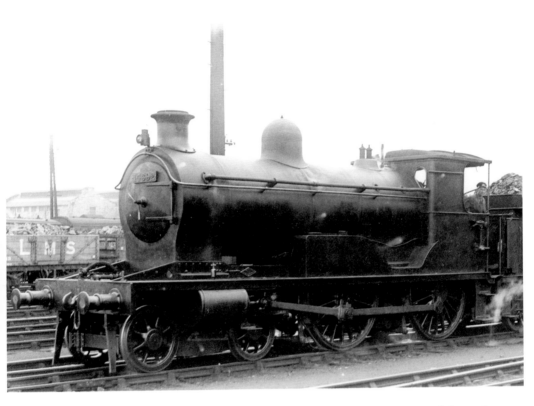

Above: HR 132, *Loch Naver*, photographed at Perth. LMS number 14392, withdrawn in 1947.
Below: HR 133, *Loch Laoghal*, LMS 14393. Withdrawn 1934.

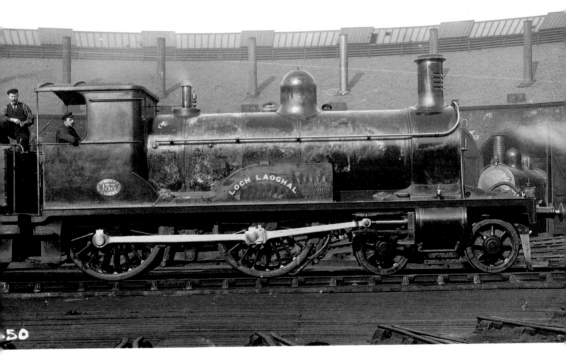

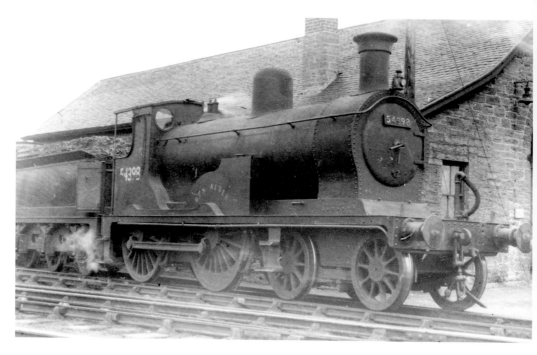

C class – Small and Large Bens

Built between 1898 and 1906, Peter Drummond's class of 4-4-0 small locomotives is divided into 'Small' and 'Large' Bens, although there was actually little difference between the two apart from boiler size. Cylinder and wheel dimensions were identical. The first batch of eight Small Bens were built by Dübs, the next nine were constructed at the Lochgorm works and the final three by the North British Locomotive Co. These were followed by six of the Large Bens, also from North British. *This page:* Two views of HR 2, *Ben Alder*, of 1898. LMS number 14398. It was not withdrawn until 1953, but despite being put aside for preservation it was scrapped in 1967.

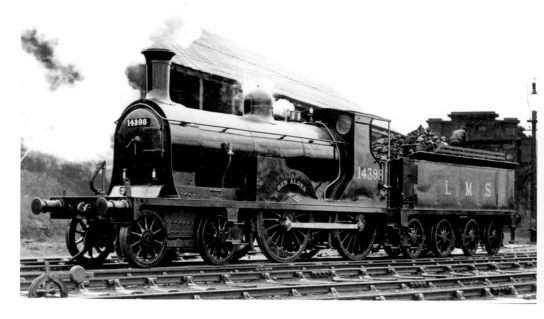

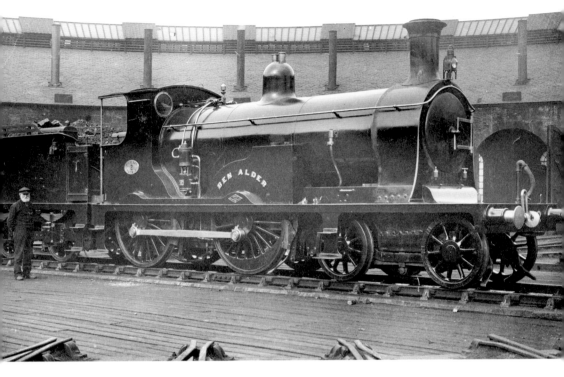

Two more images of HR 2, *Ben Alder*, both taken in front of the curved engine shed at Inverness. *Above*: In Highland Railway colours and, *below*, with LMS livery in 1937. 'Ben' is the Scottish word for a mountain. Note the eight-wheel tender.

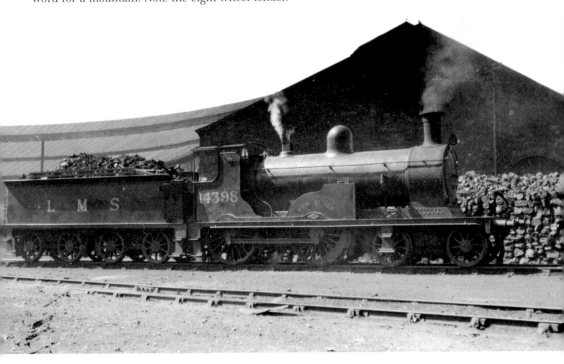

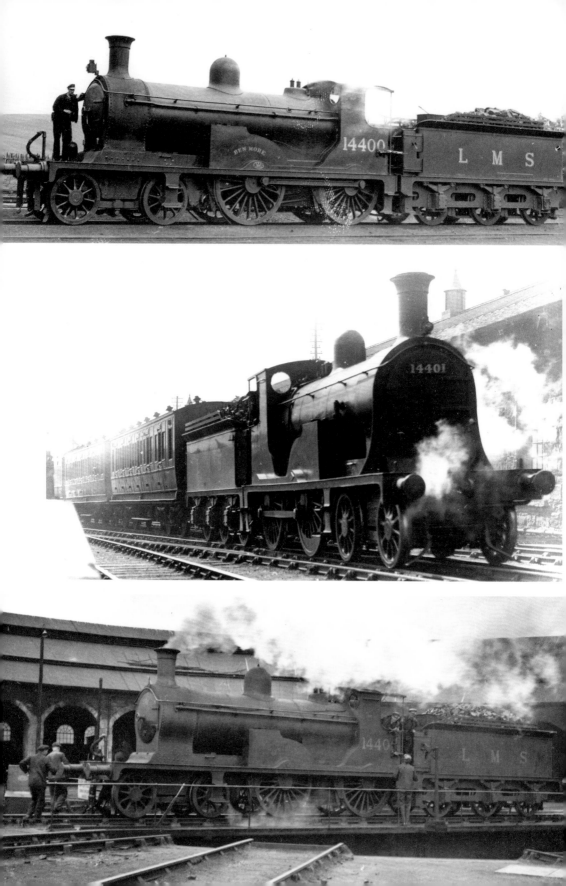

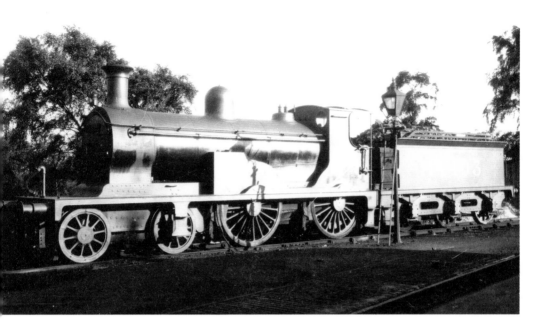

Opposite page, from the top: HR 4, *Ben More*, which became No. 14400 in its LMS days. It was withdrawn in 1946. Two images of HR 5, *Ben Vrackie*, LMS 14401, withdrawn 1948. *This page, above:* HR 7, *Ben Attrow*, LMS 14403, withdrawn in 1949. *Below:* HR 8, *Ben Clebrig*, on the double-header Dawn Express at Aviemore station in 1912. All of the engines on this spread are from the first batch of Small Bens built by Dübs & Co., of Glasgow.

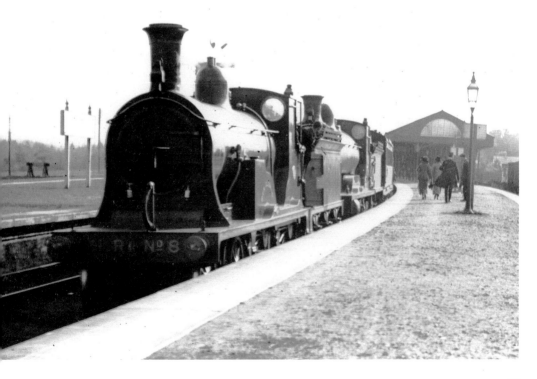

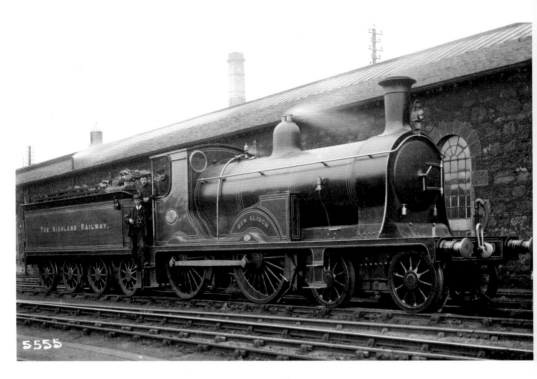

Above: A fine view of HR 10, *Ben Slioch*, beautifully turned out in what is probably its as-new condition. LMS number 14406, it was finally withdrawn in 1944. *Below:* HR 12, *Ben Hope*. LMS 14408, withdrawn in 1947. Both of these engines, and the ones on the opposite page, are part of the second batch of Small Bens built at the Lochgorm works.

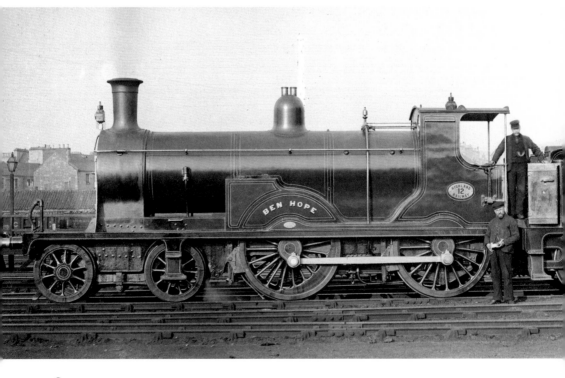

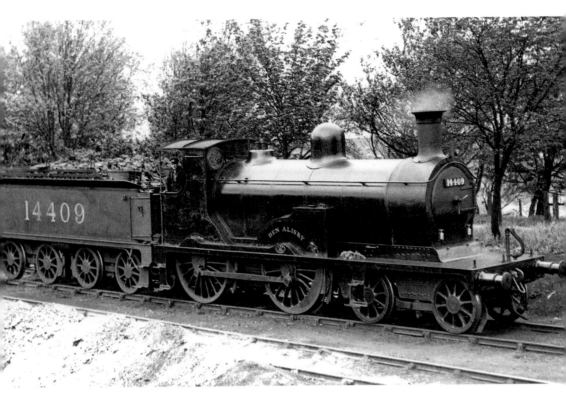

Above: HR 13, *Ben Alisky,* with LMS number 14409. It was withdrawn in 1950. *Below:* HR 14, *Ben Dearg.* Note the Highland Railway's '14' painted on the cab side rather than the usual style of cast oval engine plate. LMS 14410, withdrawn in 1949 before its allocated British Railways number, 54410, was applied.

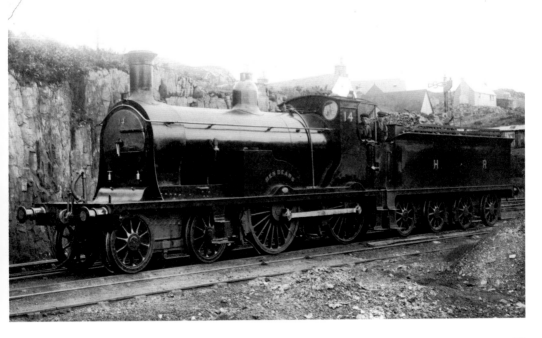

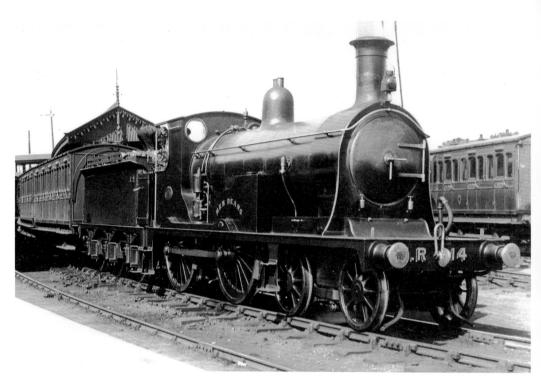

Above: HR 14, *Ben Dearg*, at Forres station and this time with its oval plate. LMS number 14410.
Below: HR 15, *Ben Loyal*, at Inverness with its LMS number, 14411. Withdrawn in 1936.

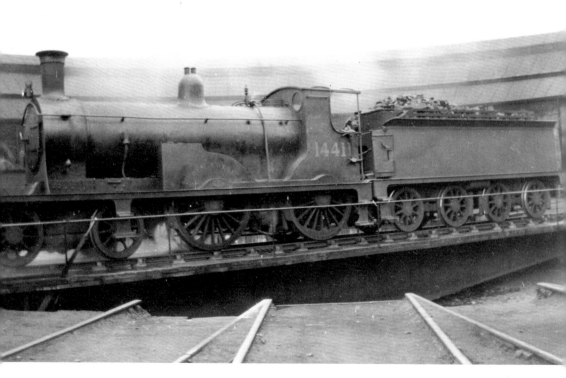

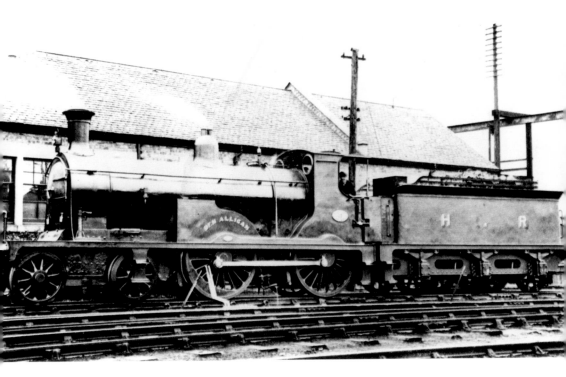

Above: HR 17, *Ben Alligan*, the last of the Smalls built by the company at Lochgorm in 1901. Later given the LMS number 14413 and withdrawn in 1933. *Below:* HR 47, *Ben a'Bhuird*, was the third of the final batch of Small Bens built by the North British Locomotive Company in 1906. It is shown at the Aviemore shed in 1923. HR 47 became LMS 14416 and was withdrawn in 1948, its British Railways number of 54416 was not applied.

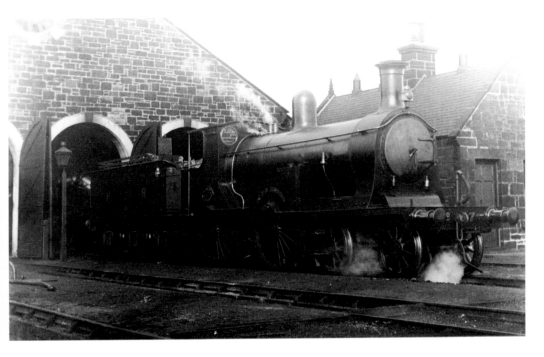

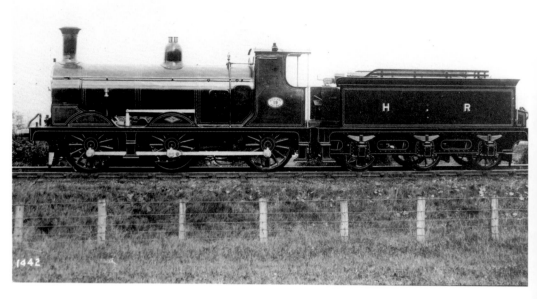

K class 'Barneys'

The only 0-6-0 tender locos built for the Highland Railway. Designed by Peter Drummond, twelve were built by Dübs and the North British Locomotive Co., between 1900 and 1907. All passed into LMS ownership in 1923. *Above:* HR 19, built in 1902 by Dübs. It became LMS 17700 and was withdrawn in 1946. *Below:* HR 22 at Inverness. LMS 17702 and withdrawn in 1949.

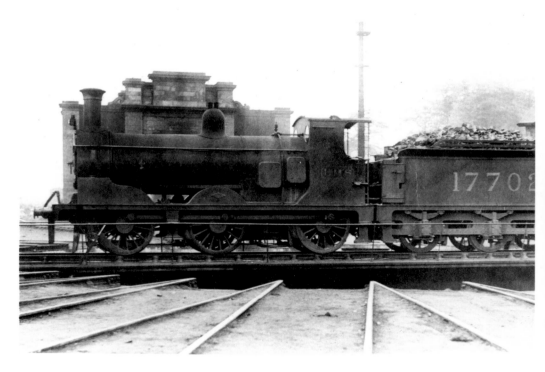

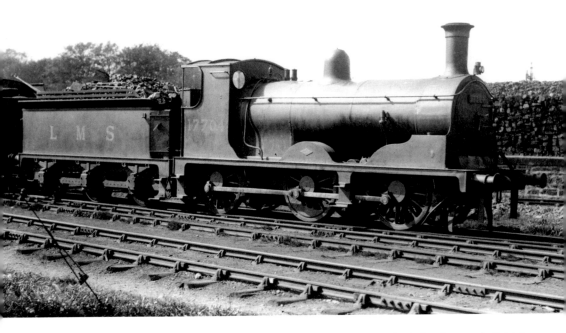

Above: LMS number 17704 tells us that this is the former HR 55, built by the North British Locomotive Co., in 1907. Withdrawn in 1946. *Below:* HR 134, the first of the Barneys, built in 1900 by Dübs & Co. LMS number 17693. It was withdrawn in 1949 before the British Railways number 57693 was applied.

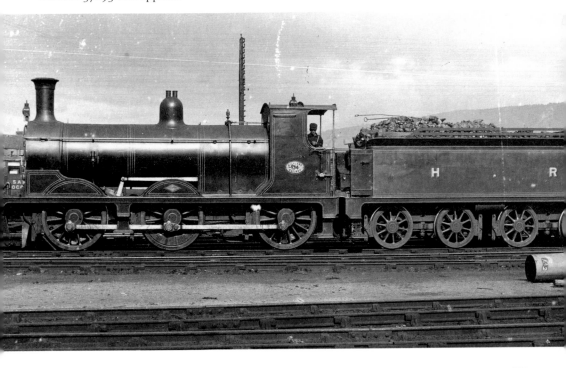

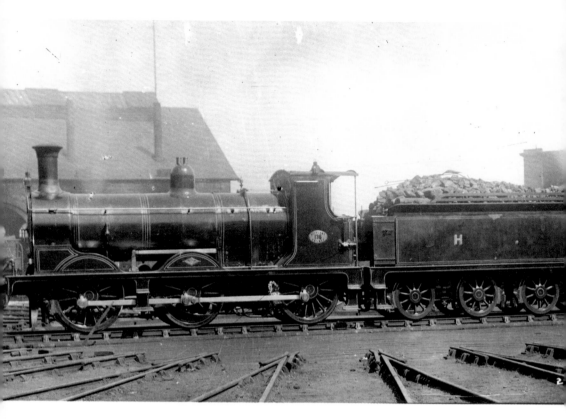

Two images of Barney class HR 136. LMS 17695, it was withdrawn by British Railways in 1952.

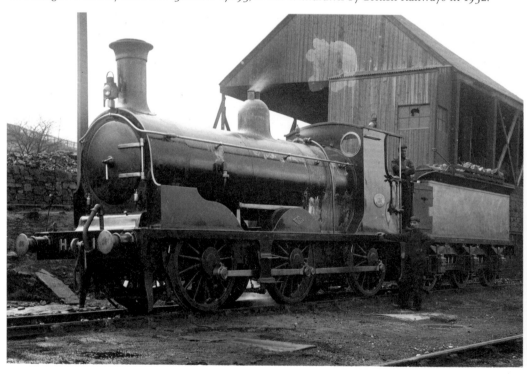

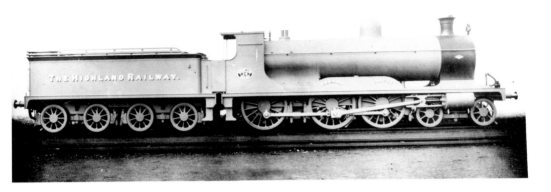

A class – Castles

Nineteen Castles were built between 1900 and 1917; ten by Dübs and a second batch of nine by North British Locomotive Co. These big 4-6-0 locos were introduced by Peter Drummond to work passenger expresses. All of the Castles passed into LMS ownership, but all had been withdrawn before the nationalisation of the railways in 1948.

Above: HR 26, *Brahan Castle*, in workshop grey. Renumbered as 14687 by the LMS, withdrawn in 1935. *Below:* A post-grouping era photograph featuring a line up of four engines, mixed types, plus three tenders inside the Lochgorm works. At the front HR 147, *Beaufort Castle*, is shown wearing its LMS number, 14682. Withdrawn in 1943.

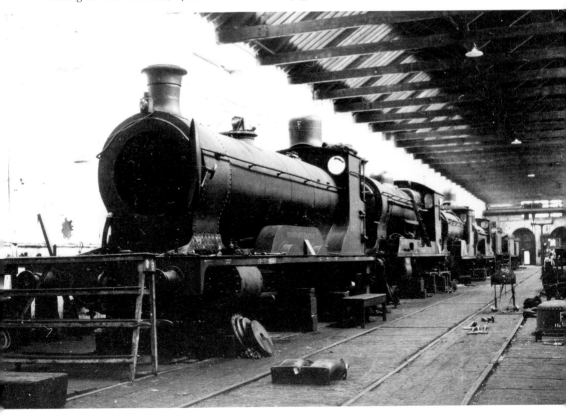

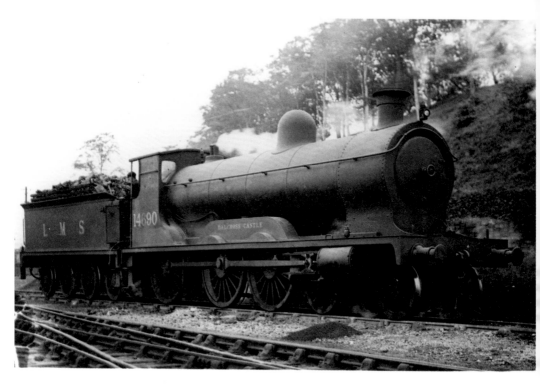

Above: HR 43, *Dalcross Castle*, is from the second batch, built by the North British Locomotive Co. in 1913. LMS number 14690, it was withdrawn in 1947. *Below:* HR 58, *Darnaway Castle*, at Aviemore Junction. This engine is from the third and final batch, which differed from the earlier ones by having larger driving wheels and longer boilers. LMS numer 14692, withdrawn 1946.

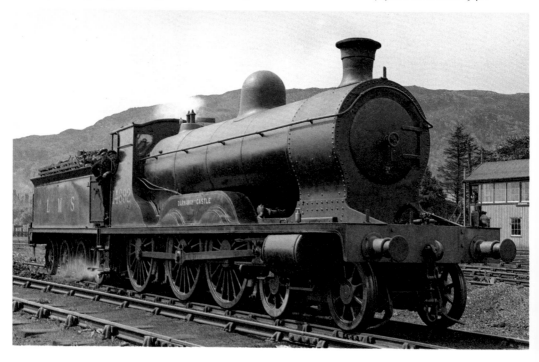

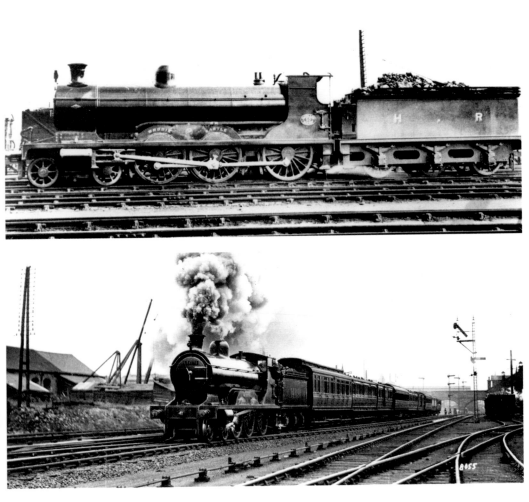

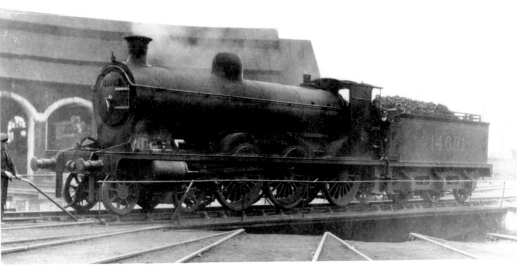

Three views of HR 50, *Brodie Castle*, in both Highland Railway and LMS days. Numbered 14691 by the LMS, this engine was withdrawn in 1938.

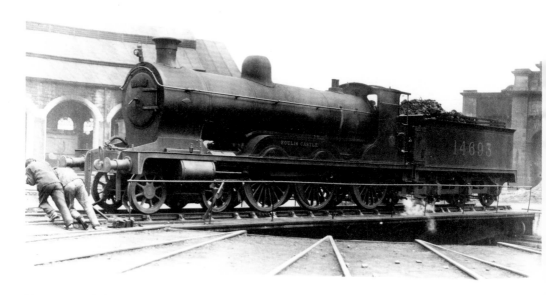

Two views of the former HR 59, *Foulis Castle*, shown in LMS livery as 14639. *Above:* Being manhandled on the turntable at Inverness roundhouse, with the corner of the ornate water tower to the right. *Foulis Castle* was withdrawn in 1935.

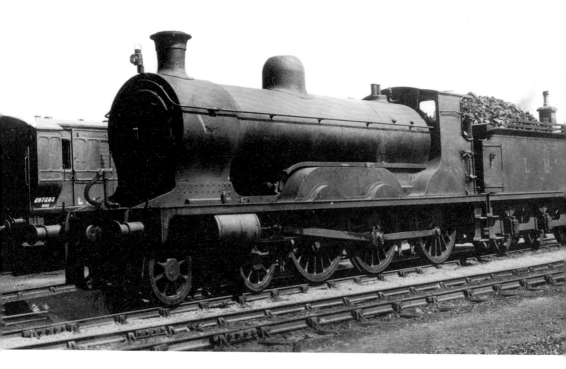

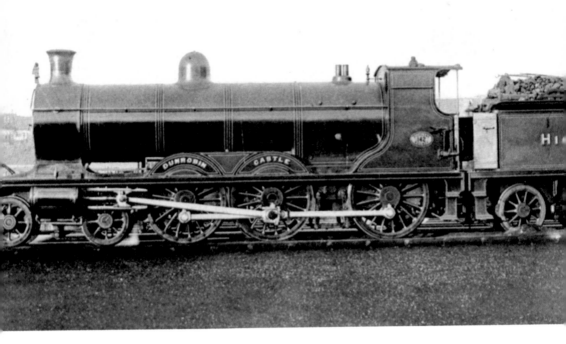

HR 142, *Dunrobin Castle,* shown in Highland Railway livery, *above,* and wearing its LMS number, 14677, *below.* Withdrawn in 1939. Both show the engine with an eight-wheel tender.

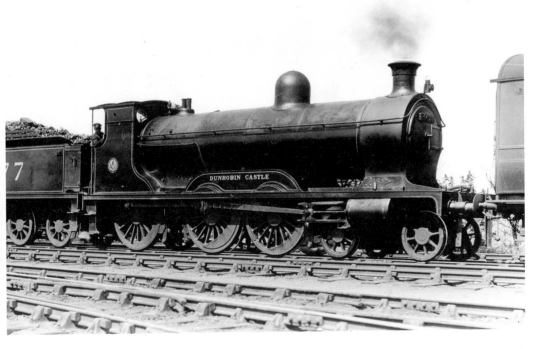

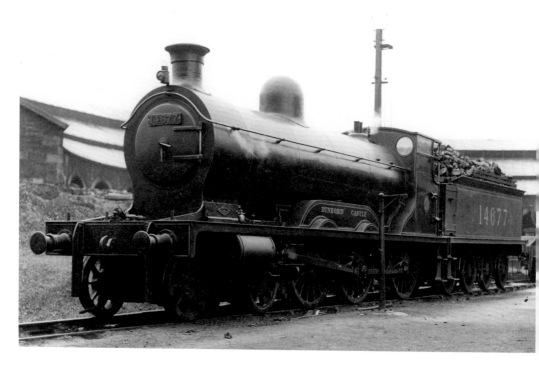

Above: Another view of HR 142, *Dunrobin Castle,* LMS 14677. *Below:* HR 143, *Gordon Castle,* from the first batch of six castles built by Dübs of Glasgow in 1900. The second engine to bear this name, it became LMS 14678 following the grouping of the railways. Withdrawn 1946.

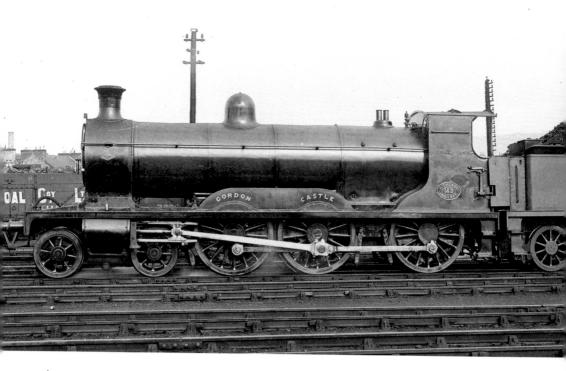

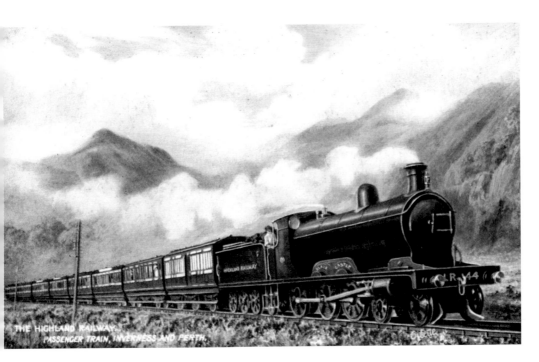

Two views of HR 144, *Blair Castle*, but are they actually the same one? *Above:* Coloured 'Oilette' postcard from Tuck. The caption on the reverses reads, 'The Highland Railway Express Train from Inverness to Perth. The 8.40 a.m. train from Inverness to Perth is composed of up-to-date stock, and has the distinction of traversing the highest railway point in Britain, at County March, 1,484 feet above sea level. The train connects at Perth with through trains for Glasgow and Edinburgh, as well as London and all parts of England ...' While the mountain scenery is an obvious addition, in all other respects the image in the postcard is identical to the photograph, *below*. *Blair Castle* became LMS 14679 and was withdrawn in 1936.

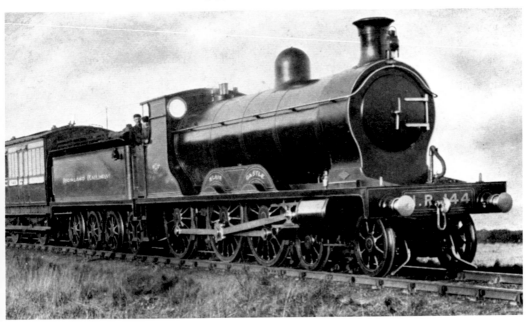

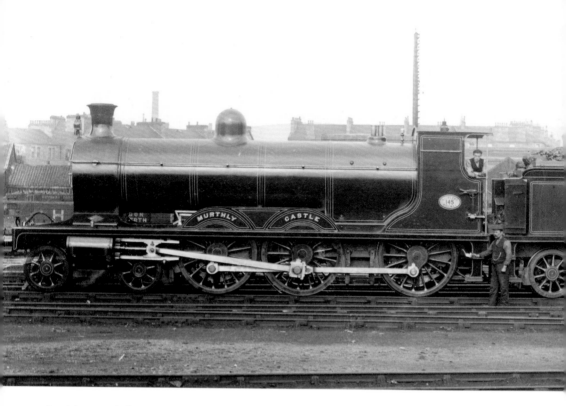

On this spread, four views of HR 145, *Murthly Castle*. One of the first batch of six built by Dübs in 1900. Under LMS ownership it became 14680 and is shown, *below*, at Inverness. *Murthly Castle* remained in service until 1930. None of the Castles survived into the British Railways era.

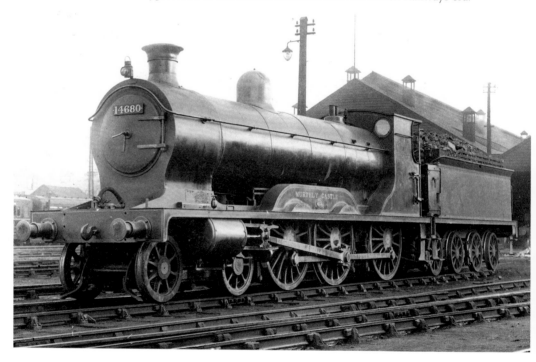

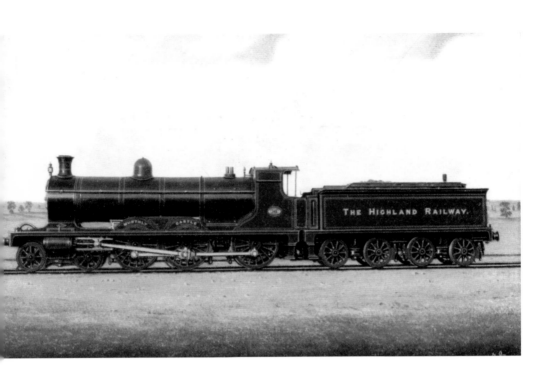

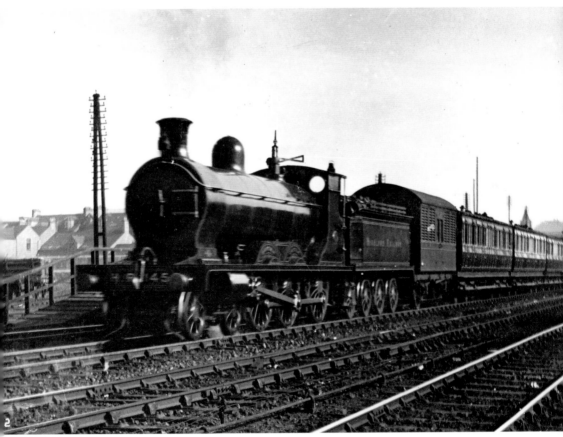

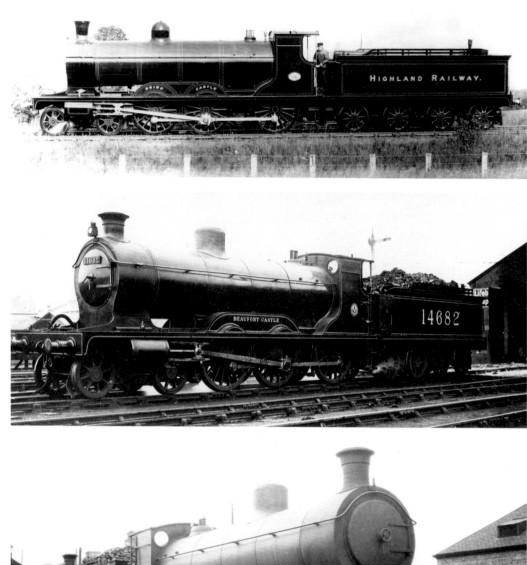

Top: HR 146, *Skibo Castle*. LMS 14681, withdrawn in 1946. *Middle and bottom:* HR 147, *Beaufort Castle*. LMS 14682. Note that in the first photo the number is on the tender while on the second it has moved to the cab, which allows engines to swap tenders without losing their numbers.

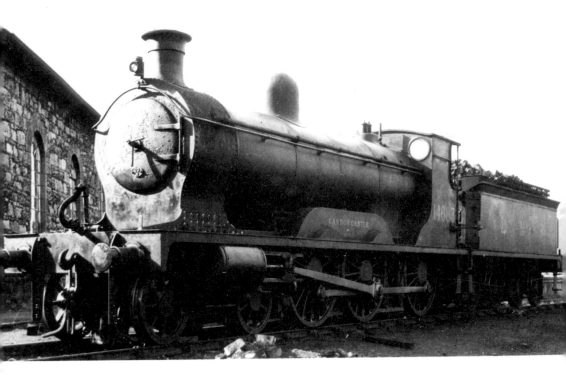

Above: Cawdor Castle is the former HR 148, now shown with it LMS 14683 number on the cab. It was withdrawn in 1937. *Below:* A schoolboy admires HR 149, *Duncraig Castle.* LMS 14684 which was withdrawn in 1940.

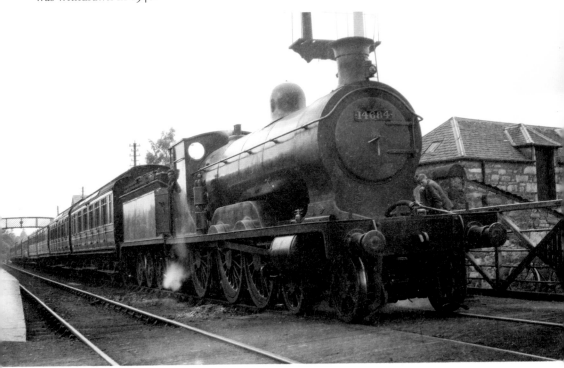

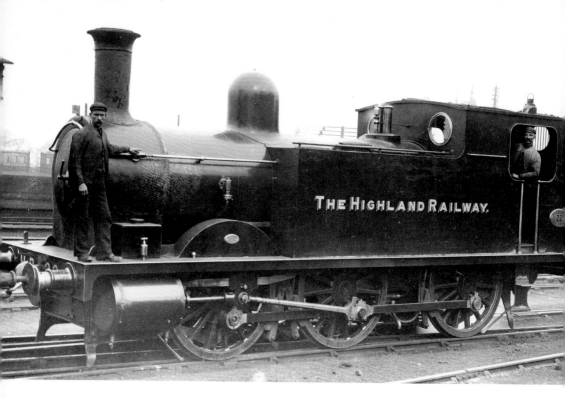

V class – the 'Scrap Tanks'

Three of these V class 0-6-0T tanks were built at the Lochgorm works in 1903–04, HR 22, HR 23 and HR 24. These powerful shunters had been assembled with wheels and boilers donated by scapped engines, giving rise to their nickname as the 'Scrap Tanks'. *Above:* HR 22 in Highland Railway colours, later to become LMS 16380. *Below:* HR24 with its LMS number, 16382. Both were withdrawn in 1930 and HR 23, not shown here, was scrapped in 1932.

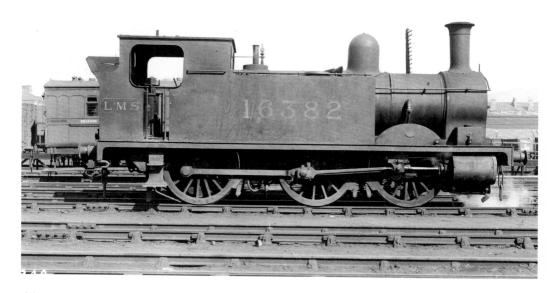

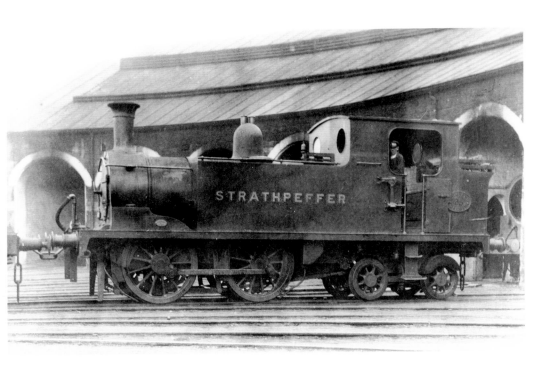

HR 25 – Strathpeffer

Not to be confused with the little HR 13 *Strathpeffer* of 1890 – *see page 23* – the name was reused for the HR 25 class of four 0-4-4 tanks built 1905–06. These were used on the smaller branch lines and were the last engines to be built at the company's Lochgorm works. The first, HR 25, is shown *above* at Inverness in 1925, still wearing its Highland Railway oval plate. It was allocated LMS number 15051, as shown *below*. This engine continued in service well into the British Railways era and was not withdrawn until 1956. The others were HR 40, HR 45 and HR 46.

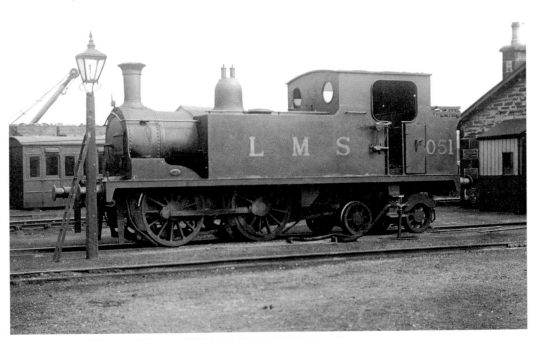

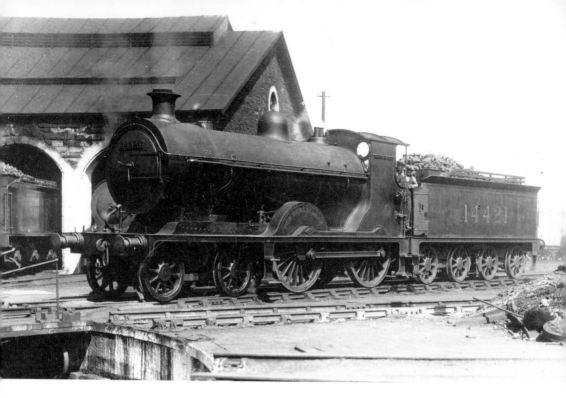

U class – Large Bens

The Large Bens were very similar to the earlier Small Ben class of 4-4-0 locomotives, but had larger boilers and they became known as the 'Large Bens' or 'Big Bens'. The first batch of four was delivered by the North British Locomotive Company in 1908, and a further two followed in 1909. *Above and below:* Two views of HR 60, *Ben Bhreac Mhor*, later renamed as *Ben Bhreac 'Mhor* in 1924. It is shown, *above,* at Inverness with LMS number 14421. Withdrawn in 1937.

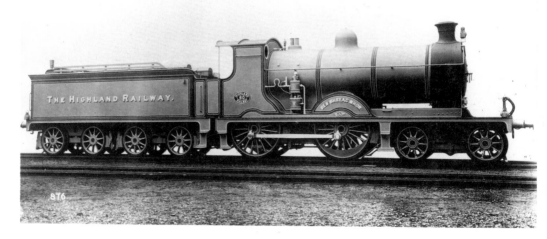

Opposite page, from the top: HR 61, *Ben na Caillach*, first of the Large Bens, originally named *Ben na Caillich*. LMS 14417, withdrawn 1936. *Middle:* HR 62, *Ben a'Chaoruinn*, renamed as *Ben Achaoruinn*. Became LMS 14422, withdrawn 1937. *Bottom:* Until 1909, HR 64, *Ben Mholach*, had been numbered as HR 66. It later became LMS 14419 and was withdrawn in 1935.

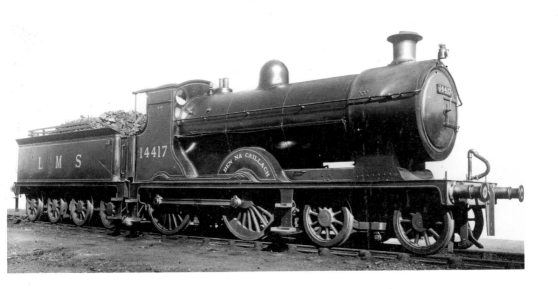

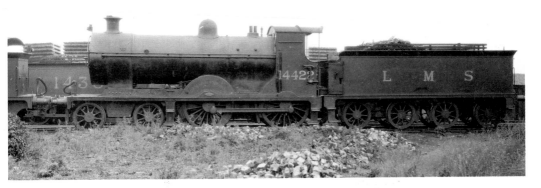

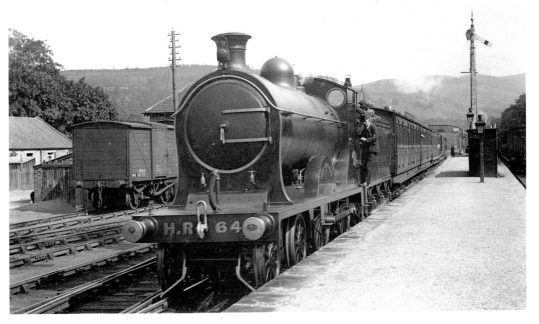

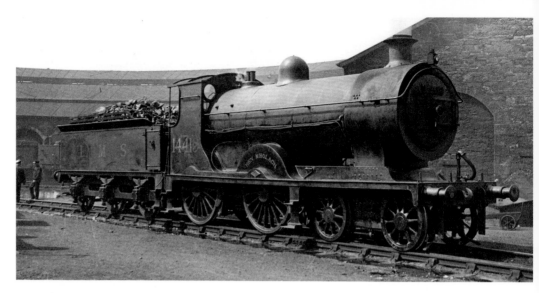

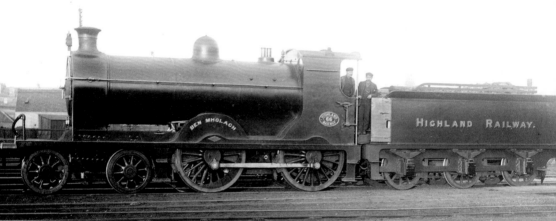

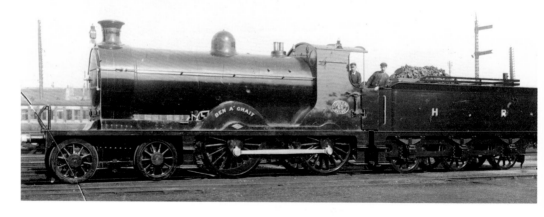

Top: HR 64, *Ben Mholach,* in its LMS guise as 14419. *Middle:* The same loco with HR 66 oval plate on the cab. *See previous page. Bottom:* HR 68, *Ben a'Chait,* which was renumbered as HR 65 in 1909. It became LMS 14420 and was withdrawn in 1934.

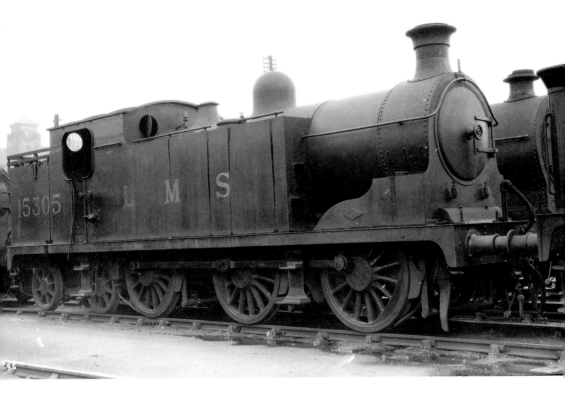

Drummond X class Medium Goods

A total of eight of these 0-6-4T large tank engines were delivered by the North British Locomotive Company, four in 1909, with a second batch of four in 1911. Derived from the K class 0-6-0 tender engines, they were intended for banking duties – providing an extra push to help trains up steep inclines. However, these tanks were also used to haul local passenger and goods services. *Above:* LMS 15305 had begun life as HR 31. It was withdrawn in 1934. *Below:* HR 39, which became LMS 15300, remained in service until 1936.

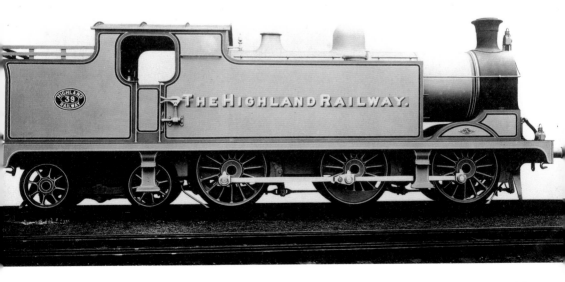

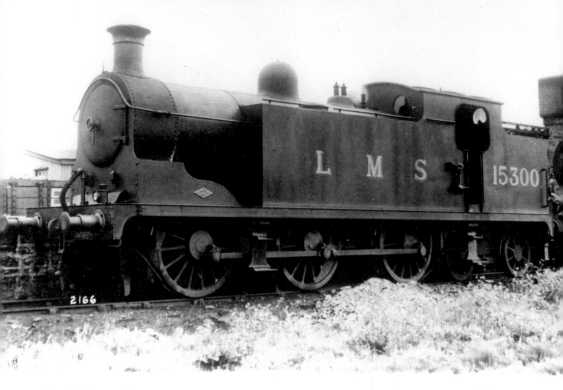

More X class Medium Goods. *Above:* HR 39 with its LMS number, 15300. *Below:* HR 43 had been HR 29 until 1913. Built in 1911 it became LMS 15304, withdrawn in 1932.

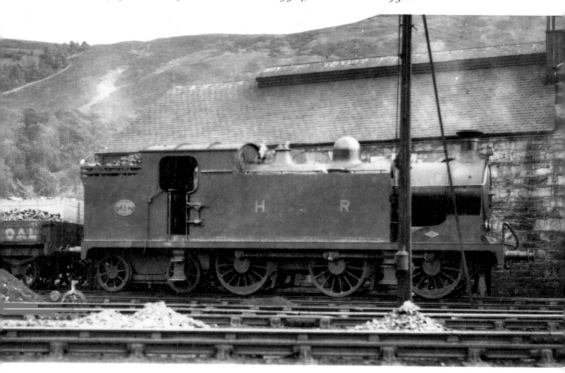

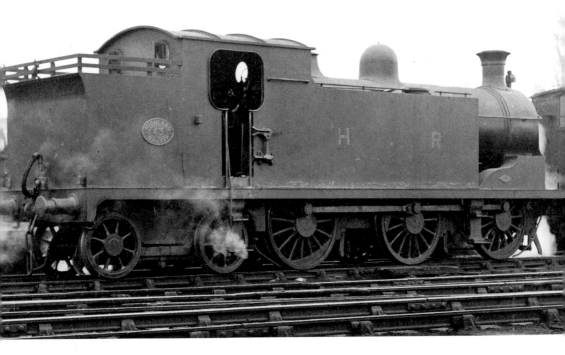

Above: Another view of HR 43 as LMS 15304. *Below:* HR 68, which had been numbered HR 65 until 1909. It became LMS 15302, withdrawn 1933.

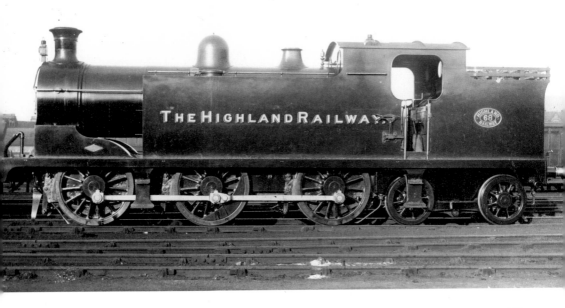

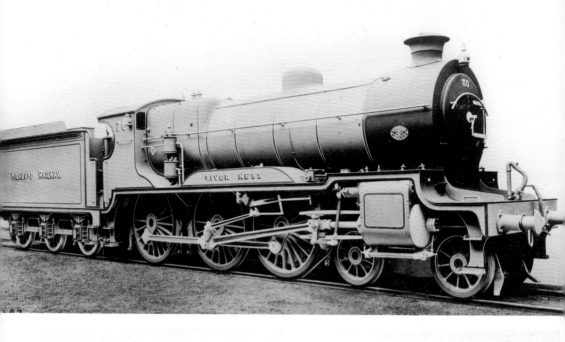

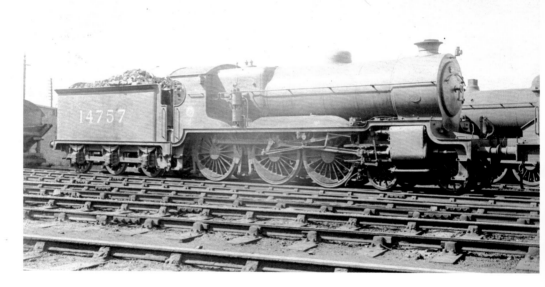

River class

Designed by Drummond's successor, F. G. Smith, the 4-6-0 River class were the biggest engines built for the Highland Railway. Six of the class were built by Hawthorn, Leslie & Co. on Tyneside. Unfortunately their axle loading of 17.75 tons exceeded the maximum loading allowed by the HR's civil engineer. On delivery they were placed in a siding and all six were sold to the Caledonian Railway. Following the grouping the LMS strengthened the mainline between Inverness and Perth and the locos returned to the Highland's rails. *Above:* Two views of HR 71, *River Spey*, the second of the class. Numbered as 939 by the Caledonian, and 14757 by the LMS. The lower image shows the engine at Balornock shed in 1928. It was withdrawn in 1936.

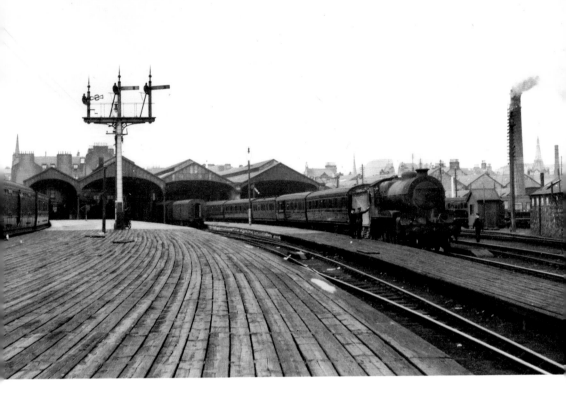

Above: River Findhorn at Inverness station. This was to have been HR 73, it became No. 941 under the Caledonian and renumbered as 14759 by the LMS. Withdrawn in 1939. *Below:* An unidentified River class engine, LMS era.

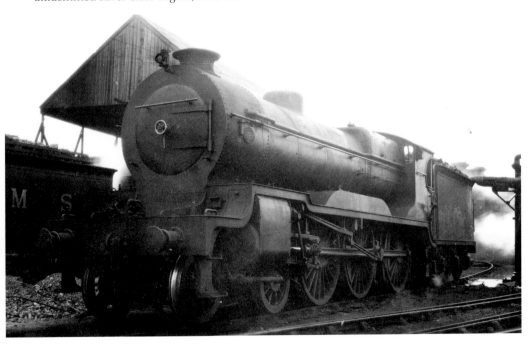

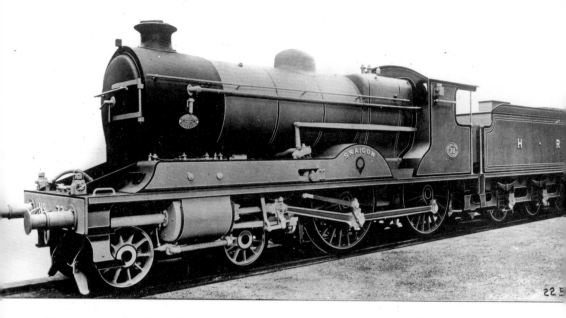

No. 73 class – 'Sanigows'

Designed by Christopher Cumming, only two of this class were built by Hawthorn Leslie in 1916 as powerful 4-4-0 engines for passenger services. They had 20 x 26-inch cylinders with Walschaerts valve gear. *This page:* HR 73, *Snaigow*, the first of the class. It became 14522 in LMS service and was withdrawn in 1936.

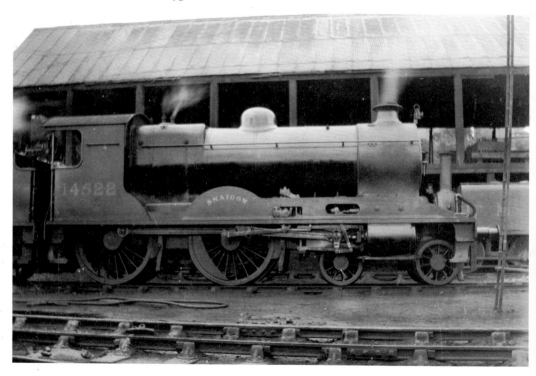

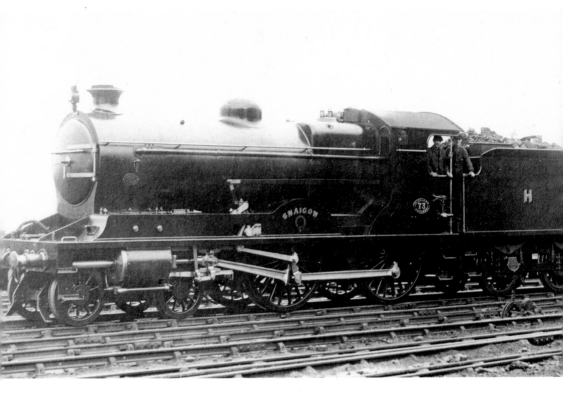

Above: Another view of HR 73, *Snaigow*. *Below:* The only other engine of this class, HR 74, *Durn*. It was given the LMS number 14523 and remained in service until 1935.

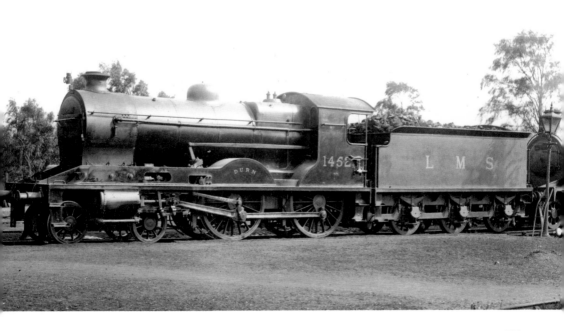

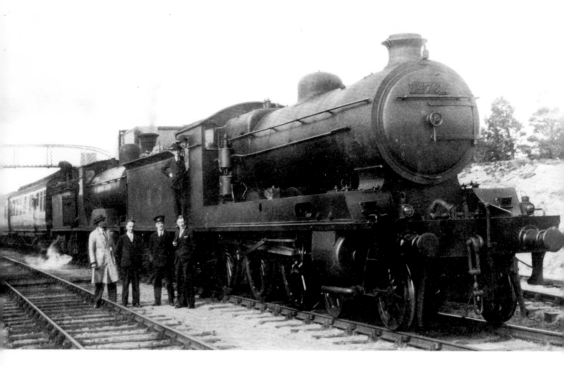

Clan class

The Clan Goods were a class of eight 4-6-0 goods engines designed by Christopher Cummings and built by Hawthorn Leslie between 1917 and 1919. The Clan class of eight passenger engines, built in 1909, were very similar in appearance but had 21 x 26-inch outside cylinders with Walschaerts valve gear. *This page:* First of the Clans, HR 49, *Clan Campbell*, which became LMS 14762 and remained in service until June 1947.

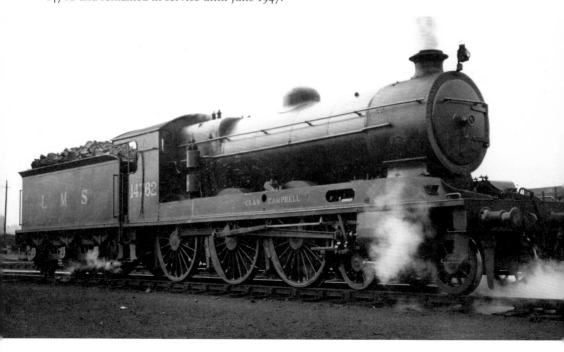

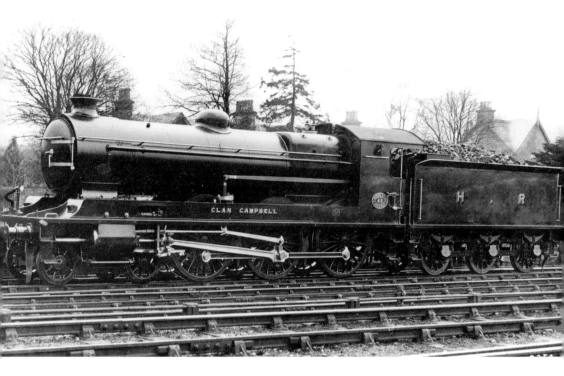

Above: HR 49, *Clan Campbell,* again. This time in its Highland Railway livery. *Below:* In stark contrast HR 51, *Clan Fraser,* as LMS 14763 in Crimson Lake on a Tuck's postcard. The caption tells us that, 'These locomotives, named after the Scottish Clans, are used for the difficult routes of the LMS railway in the Highlands and take the important trains from the south onwards from Perth'. This engine was withdrawn towards the end of the war in 1944.

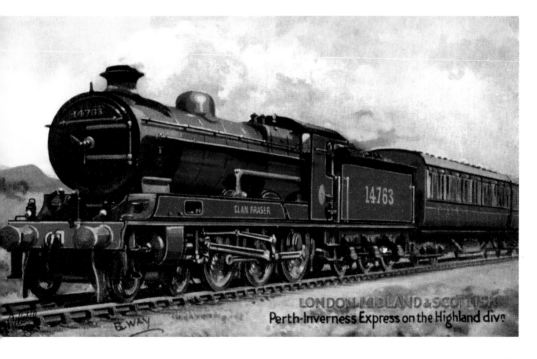

LONDON MIDLAND & SCOTTISH
Perth-Inverness Express on the Highland div⁹

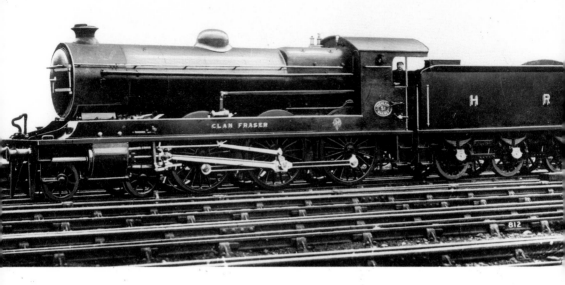

Above: Another view of *Clan Fraser*, HR 51. *Below:* HR 52, *Clan Munro,* which went on to become LMS 14764. It was one of only two of the Clans to be allocated a British Railways number – the other being HR 55, *Clan Mackinnon – see page 83.*

Opposite page: Three images of HR 53, *Clan Stewart*, in various guises, starting with the Highland Railway livery. In LMS service it became 14765 and remained in use until 1945. Note in particular that the top picture shows HR 53's tender loaded with oil tanks instead of coal. The company experimented with oil firing in 1921 and although apparently successful it was not applied to other engines. It is not known when *Clan Stewart* reverted to coal.

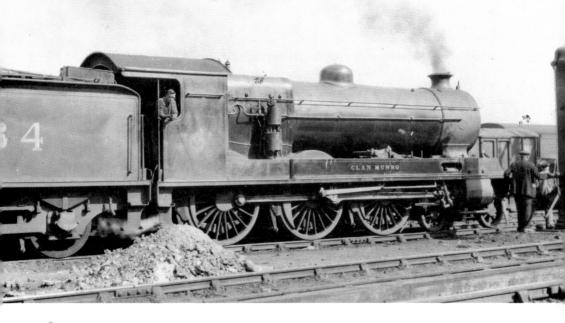

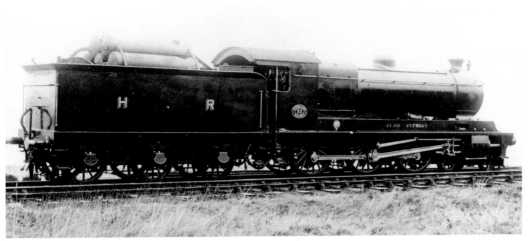

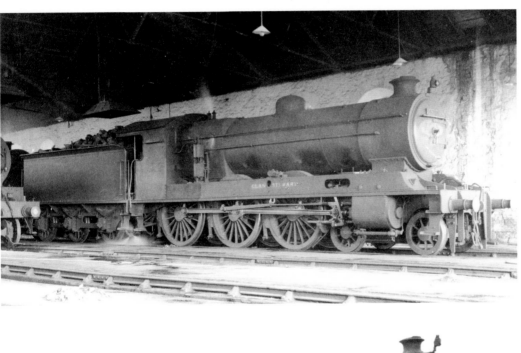

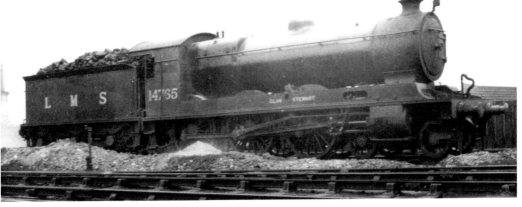

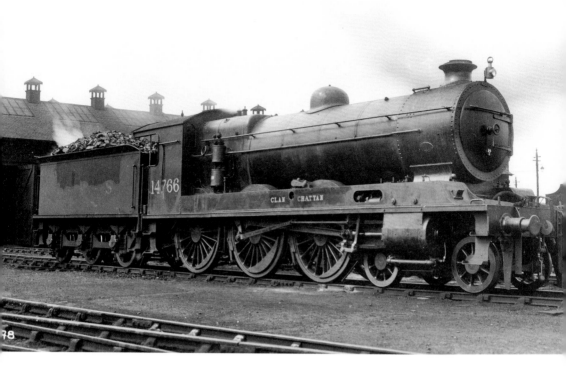

This page: HR 54, *Clan Chattan*, built in 1921 by Hawthorn Leslie & Co. LMS number is 14766, and it was withdrawn in 1944.

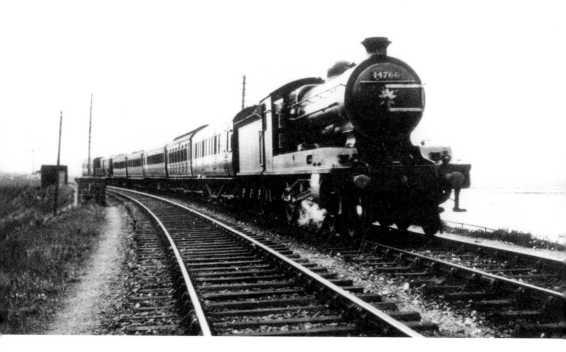

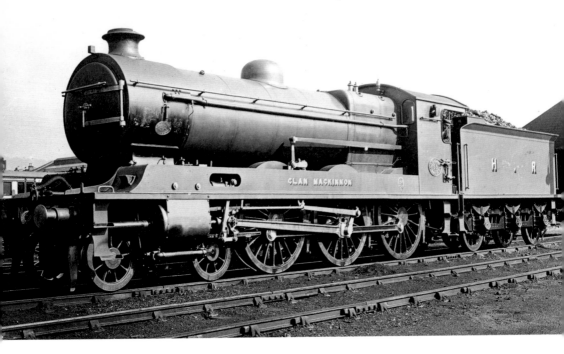

Above: HR 55, *Clan Mackinnon*, renumbered by the LMS as 14767, was the only one of the class to have its British Railways number applied, 54767. *Clan Mackinnon* was withdrawn from service in 1950. *Below:* HR 56, *Clan Mackenzie*. LMS 14768, withdrawn in 1945.

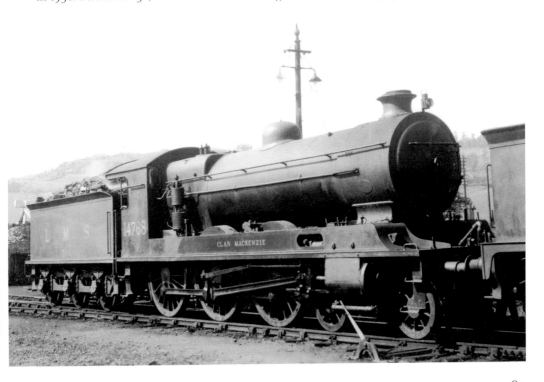

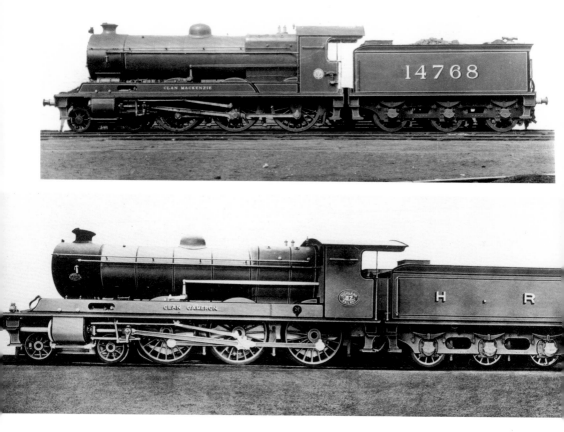

Top: HR 56, *Clan Mackenzie,* in LMS days as 14768. *Middle and below:* HR 57, *Clan Cameron.* This was the last of the Clan class when built in 1921, and it became LMS 14769 only a couple of years later.

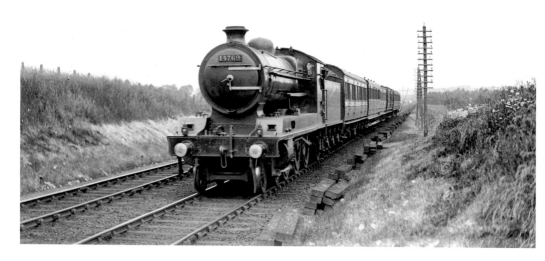

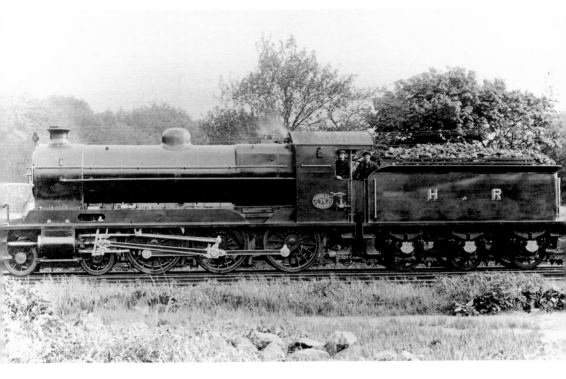

Clan Goods

Eight of this class of 4-6-0 goods locos were built by Hawthorn Leslie & Co. between 1917 and 1919. This was the twilight of the Highland Railway and all eight went on to serve with the LMS, all but one with British Railways. *This page:* HR 75, the first of the class. It became LMS 17950 and was renumbered by BR as 57950.

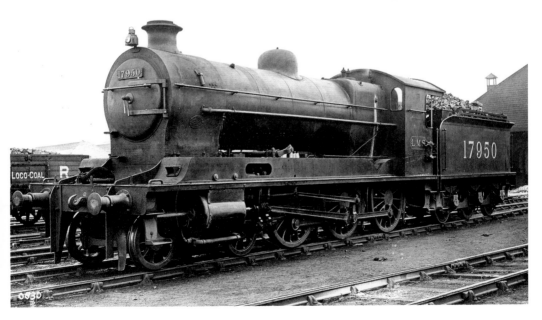

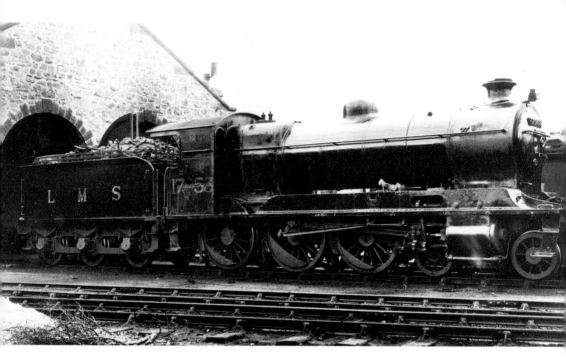

This page: HR 78, built in 1918. LMS 17953, British Railways 57953 and withdrawn in 1948 before the number was applied.

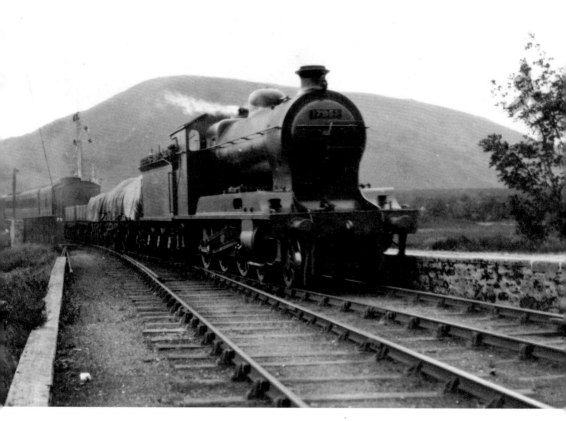

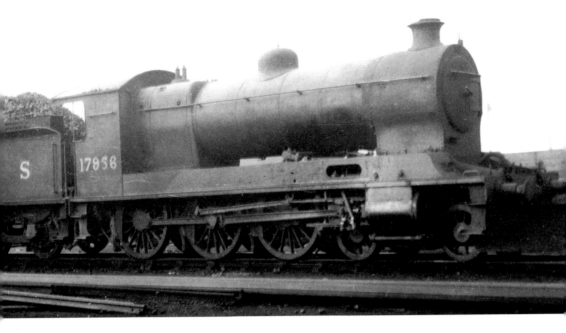

Top: HR 81 at Inverness. LMS 17956, then British Railways 57956 and withdrawn in 1952. *Below:* HR 82, photographed as LMS 17957 at Kyle of Lochalsh. Last of the Clan Goods, it was withdrawn in 1946.

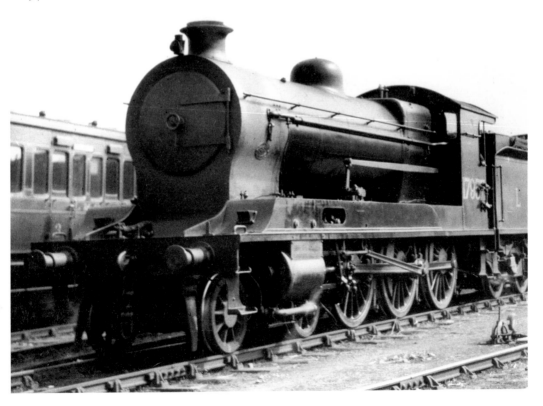

Locations

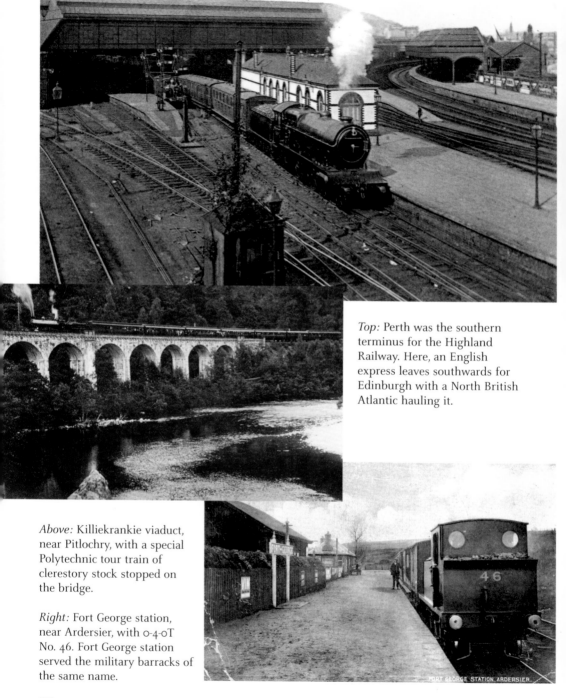

English Express, leaving Perth General Station

Top: Perth was the southern terminus for the Highland Railway. Here, an English express leaves southwards for Edinburgh with a North British Atlantic hauling it.

Above: Killiekrankie viaduct, near Pitlochry, with a special Polytechnic tour train of clerestory stock stopped on the bridge.

Right: Fort George station, near Ardersier, with 0-4-0T No. 46. Fort George station served the military barracks of the same name.

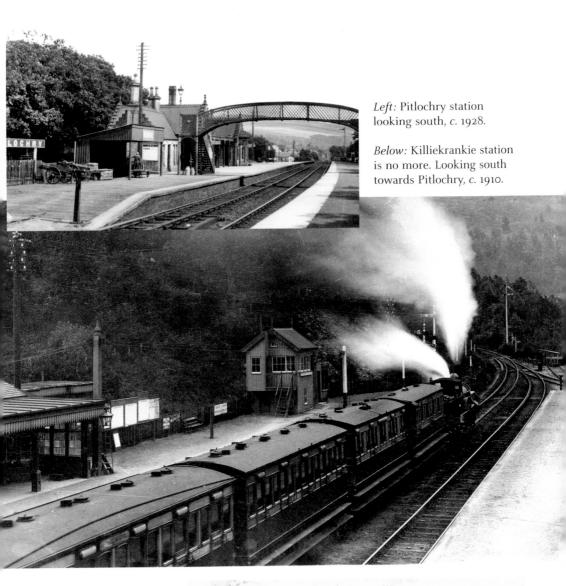

Left: Pitlochry station looking south, *c.* 1928.

Below: Killiekrankie station is no more. Looking south towards Pitlochry, *c.* 1910.

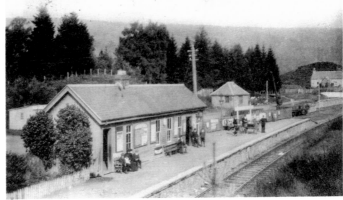

Right: Grandtully station was on the Aberfeldy branch of the Highland Railway. It opened on 3 July 1865 and closed, along with the rest of the branch, on 3 May 1965.

List of Locomotives

William Stroudley 1855–69

Stroudley 0-6-0T tanks

No.	Name	Builder	Built	LMS No.	BR No.	Withdrawn
HR 56	*Balnain*	Lochgorm	1869	LMS 16118	-	1926
	(Renamed *Dornoch*, renumbered 56A and 56B)					
HR 57	*Lochgorm*	Lochgorm	1872	LMS 16119	-	1932
	(Renumbered 57A and 57B)					
HR 16	*St Martins*	Lochgorm	1874	LMS 16383	-	1928
	(Renamed *Fort George*, renumbered 49 and 49A)					

David Jones 1870–96

Jones F class – 'Dukes'

No.	Name	Builder	Built	LMS No.	BR No.	Withdrawn
HR 60	*Bruce*	Dübs	1874	-	-	1909
	(Renamed *Sutherland*)					
HR 61	*Sutherland*	Dübs	1874	-	-	1907
	(Renamed *Duke*)					
HR 62	*Perthshire*	Dübs	1874	-	-	1909
	(Renamed *Stemster, Huntingtower* and *Aultwherrie*)					
HR 63	*Inverness-shire*	Dübs	1874	-	-	1907
	(Renamed *Inverness*)					
HR 64	*Morayshire*	Dübs	1874	-	-	1909
	(Renamed *Seafield*)					
HR 65	*Nairnshire*	Dübs	1874	-	-	1909
	(Renamed *Dalraddy*)					
HR 66	*Ross-shire*	Dübs	1874	-	-	1907
	(Renamed *Ardvuela*)					
HR 67	*The Duke*	Dübs	1874	-	-	1923
	(Renamed *Cromatie*, renumbered 67A and 70A)					
HR 68	*Caithness-shire*	Dübs	1874	-	-	1907
	(Renamed *Caithness* and *Muirtown*)					
HR 69	*The Lord Provost*	Dübs	1874	-	-	1909
	(Renamed *Sir James*, and *Aldourie*)					
HR 4	*Ardross*	Lochgorm	1876	-	-	1913
	(Renamed *Auchtertyre*, renumbered 31 and 31A)					
HR 71	*Clachnacuddin*	Lochgorm	1883	-	-	1915
	(Renumbered 71A)					
HR 72	*Bruce*	Lochgorm	1884	-	-	1923
	(Renamed *Grange*, renumbered 72A)					
HR 73	*Thurlow*	Lochgorm	1885	-	-	1923
	(Renamed *Rosehaugh*, renumbered 73A)					

No.	Name	Builder	Built	LMS No.	BR No.	Withdrawn
HR 74	*Beaufort*	Lochgorm	1885	-	-	1913
HR 75	*Breadalbane*	Lochgorm	1886	-	-	1923
	(Renumbered 75A)					
HR 84	*Dochfour*	Lochgorm	1888	-	-	1923
	(Renumbered 84A)					
HR 1	*Raigmore*	Hawthorns	1855	-	-	1873
	(Originally a 2-2-2)					
HR 3	*Ballindalloch*	Lochgorm	1877	-	-	1910
	(Renumbered 30)					

Jones 4-4-0T O class

No.	Name	Builder	Built	LMS No.	BR No.	Withdrawn
HR 58	*Burghead*	Lochgorm	1878	LMS 15011	-	1928
	(Renumbered 58A and 58B)					
HR 59	*Highlander*	Lochgorm	1879	LMS 15010	-	1933
	(Renumbered 59A and 59B)					
HR 17	*Breadalbane*	Lochgorm	1879	LMS 15012	-	1929
	(Renamed *Aberfeldy*, renumbered 50, 50A and 50B)					

Jones 4-4-0 L class – Skye Bogies

No.	Name	Builder	Built	LMS No.	BR No.	Withdrawn
HR 70	-	Lochgorm	1882	LMS 14277	-	1930
	(Swapped numbers with HR 67)					
HR 85	-	Lochgorm	1892	-	-	1923
	(Renumbered 85A)					
HR 86	-	Lochgorm	1893	LMS 14279	-	1927
HR 87	-	Lochgorm	1893	LMS 14280	-	1926
HR 88	-	Lochgorm	1895	LMS 14281	-	1926
HR 5	-	Lochgorm	1897	LMS 14282	-	1929
	(Renumbered 34)					
HR 6	-	Lochgorm	1897	LMS 14283	-	1929
	(Renumbered 33)					
HR 7	-	Lochgorm	1898	LMS 14284	-	1930
	(Renumbered 34)					
HR 8	-	Lochgorm	1901	LMS 14285	-	1928

Jones 4-4-0 E class – Clyde Bogies

No.	Name	Builder	Built	LMS No.	BR No.	Withdrawn
HR 76	*Bruce*	Clyde	1886	-	-	1923
HR 77	*Lovat*	Clyde	1886	-	-	1918
	(Renumbered 77A)					
HR 78	*Lochalsh*	Clyde	1886	-	-	1923
	(Renumbered 78A)					
HR 79	*Atholl*	Clyde	1886	-	-	1923
	(Renumbered 79A)					

HR 80	*Stafford*	Clyde	1886	-	-	1923
	(Renumbered 80A)					
HR 81	*Colville*	Clyde	1886	-	-	-
	(Renumbered 81A)					
HR 82	*Fife*	Clyde	1886	LMS 14278	-	1930
	(Renamed *Durn*, renumbered 82A)					
HR 83	*Cadboll*	Clyde	1886	-	-	1923
	(Renamed *Monkland*, renumbered 83A)					

Jones 0-4-4 – Strathpeffer

HR 13	*Strathpeffer*	Lochgorm	1890	LMS 15050	-	1929
	(Renamed *Lybster*, renumbered 53 and 53A)					

Jones 4-4-0 D class – Straths

HR 89	*Sir George*	Neilson	1892	LMS 14271	-	1930
HR 90	*Tweeddale*	Neilson	1892	-	-	1923
	(Renamed *Grandtully*, renumbered 90A)					
HR 91	*Strathspey*	Neilson	1892	-	-	1923
	(Renumbered 91A)					
HR 92	*Strathdearn*	Neilson	1892	LMS 14272	-	1930
	(Renamed *Glendean*, renumbered 92A)					
HR 93	*Strathnairn*	Neilson	1892	-	-	1923
	(Renumbered 93A)					
HR 94	*Strathtay*	Neilson	1892	LMS 14273	-	1924
HR 95	*Strathcarron*	Neilson	1892	LMS 14274	-	1930
HR 96	*Glentilt*	Neilson	1892	-	-	1923
	(Renumbered 96A)					
HR 97	*Glenmore*	Neilson	1892	-	-	1923
	(Renumbered 97A)					
HR 98	*Glentrium*	Neilson	1892	LMS 14275	-	1930
HR 99	*Glentomie*	Neilson	1892	-	-	1923
	(Renumbered 99A)					
HR 100	*Glenbruar*	Neilson	1892	LMS 14276	-	1930

Jones 4-4-0T P class – 'Yankee Tanks'

HR 101	-	Dübs	1892	LMS 15013	-	1934
	(Renumbered 101A and back to 101)					
HR 102	-	Dübs	1892	LMS 15014	-	1934
	(Named *Munlochy*)					
HR 11	-	Dübs	1893	-	-	-
HR 14	-	Dübs	1893	LMS 15017	-	1927
	(Named *Portessie*, renumbered 51A, 51B)					
HR 15	-	Dübs	1893	LMS 15016	-	1927
	(Named *Fortrose*, renumbered 52, 52A and 52B					

Jones 4-6-0 I class 'Big Goods'

HR 103	-	Sharp, Stewart	1894	LMS 17916	-	1934
		(Restored by the LMS and now displayed at the Museum of Transport in Glasgow)				
HR 104	-	Sharp, Stewart	1894	LMS 17917	-	1939
HR 105	-	Sharp, Stewart	1894	LMS 17918	-	1933
HR 106	-	Sharp, Stewart	1894	LMS 17919	-	1934
HR 107	-	Sharp, Stewart	1894	LMS 17920	-	1937
HR 108	-	Sharp, Stewart	1894	LMS 17921	-	1930
HR 109	-	Sharp, Stewart	1894	LMS 17922	-	1929
HR 110	-	Sharp, Stewart	1894	LMS 17923	-	1935
HR 111	-	Sharp, Stewart	1894	LMS 17924	-	1934
HR 112	-	Sharp, Stewart	1894	LMS 17925	-	1940
HR 113	-	Sharp, Stewart	1894	LMS 17926	-	1939
HR 114	-	Sharp, Stewart	1894	LMS 17927	-	1936
HR 115	-	Sharp, Stewart	1894	LMS 17928	-	1933
HR 116	-	Sharp, Stewart	1894	LMS 17929	-	1936
HR 117	-	Sharp, Stewart	1894	LMS 17930	-	1939

Jones 4-4-0 B or Loch class

HR 119	*Loch Insh*	Dübs	1896	LMS 14379	BR 54379	1948
HR 120	*Loch Ness*	Dübs	1896	LMS 14380	-	1940
HR 121	*Loch Ericht*	Dübs	1896	LMS 14381	-	1940
HR 122	*Loch Moy*	Dübs	1896	LMS 14382	-	1940
HR 123	*Loch an Dorb*	Dübs	1896	LMS 14383	-	1934
HR 124	*Loch Lagan*	Dübs	1896	LMS 14384	-	1938
HR 125	*Loch Tay*	Dübs	1896	LMS 14385	-	1950
HR 126	*Loch Tummel*	Dübs	1896	LMS 14386	-	1938
HR 127	*Loch Garry*	Dübs	1896	LMS 14387	-	1930
HR 128	*Loch Luichart*	Dübs	1896	LMS 14388	-	1930
HR 129	*Loch Maree*	Dübs	1896	LMS 14389	-	1931
HR 130	*Loch Fannich*	Dübs	1896	LMS 14390	-	1937
HR 131	*Loch Shin*	Dübs	1896	LMS 14391	-	1941
HR 132	*Loch Naver*	Dübs	1896	LMS 14392	-	1947
HR 133	*Loch Laoghal*	Dübs	1896	LMS 14393	-	1934
	(Renamed *Loch Laochal*)					
HR 70	*Loch Ashie*	North British	1917	LMS 14394	-	1936
HR 71	*Loch Garve*	North British	1917	LMS 14395	-	1935
HR 72	*Loch Ruthven*	North British	1917	LMS 14396	-	1934

Peter Drummond 1896–1912

Drummond 4-4-0 C class Small Bens

First batch

HR 1	Ben-y-Gloe	Dübs & Co.	1898	LMS 14397	BR 54397	1949
HR 2	Ben Adler	Dübs & Co	1898	LMS 14398	BR 54398	1953
HR 3	Ben Wyvis	Dübs & Co.	1898	LMS 14399	BR 54399	1952
HR 4	Ben More	Dübs & Co.	1899	LMS 14400	-	1946
HR 5	Ben Vrackie	Dübs & Co.	1899	LMS 14401	BR 54401	1948
HR 6	Ben Armin	Dübs & Co.	1899	LMS 14402	-	1939
HR 7	Ben Attrow	Dübs & Co.	1899	LMS 14403	BR 54403	1949
HR 8	Ben Clebrig	Dübs & Co.	1899	LMS 14404	BR 54404	1950

Second batch

HR 9	Ben Rinnes	Lochgorm	1899	LMS 14405	-	1944
HR 10	Ben Slioch	Lochgorm	1899	LMS 14406	-	1947
HR 11	Ben Macdhui	Lochgorm	1899	LMS 14407	-	1931
HR 12	Ben Hope	Lochgorm	1900	LMS 14408	-	1947
HR 13	Ben Alisky	Lochgorm	1900	LMS 14409	BR 54409	1950
HR 14	Ben Dearg	Lochgorm	1900	LMS 14410	BR 54410	1949
HR 15	Ben Loyal	Lochgorm	1900	LMS 14411	-	1936
HR 16	Ben Avon	Lochgorm	1901	LMS 14412	-	1947
HR 17	Ben Alligan	Lochgorm	1901	LMS 14413	-	1933

Third batch

HR 38	Ben Udlaman	North British	1906	LMS 14414	-	1933
HR 41	Ben Bhach Ard	North British	1906	LMS 14415	BR 54415	1948
HR 47	Ben a'Bhuird	North British	1906	LMS 14416	BR 54416	1948

Drummond 0-6-0 K class – Barneys

HR 134	-	Dübs	1900	LMS 17693	BR 57693	1949
HR 135	-	Dübs	1900	LMS 17694	BR 57694	1950
HR 136	-	Dübs	1900	LMS 17695	BR 67695	1952
HR 137	-	Dübs	1900	LMS 17696	-	1946
HR 138	-	Dübs	1900	LMS 17697	BR 57697	1951
HR 139	-	Dübs	1900	LMS 17698	BR 57698	1951
HR 18	-	Dübs	1902	LMS 17699	BR 57699	1949
HR 19	-	Dübs	1902	LMS17700	-	1946
HR 20	-	Dübs	1902	LMS 17701	-	1936
HR 21	-	Dübs	1902	LMS 17702	BR 57702	1949
HR 36	-	North British	1907	LMS 17703	-	1947
HR 55	-	North British	1907	LMS 17704	-	1946

Drummond 4-6-0 A class – Castles

HR 140	Taymouth Castle	Dübs	1900	LMS 14675	-		1939
HR 141	Ballindalloch Castle	Dübs	1900	LMS 14676	-		1937
HR 142	Dunrobin Castle	Dübs	1900	LMS 14677	-		1939
HR 143	Gordon Castle	Dübs	1900	LMS 14678	-		1946
HR 144	Blair Castle	Dübs	1900	LMS 14679	-		1936
HR 145	Murthly Castle	Dübs	1900	LMS 14680	-		1930
HR 146	Skibo Castle	Dübs	1902	LMS 14681	-		1946
HR 147	Beaufort Castle	Dübs	1902	LMS 14682	-		1943
HR 148	Cawdor Castle	Dübs	1902	LMS 14683	-		1937
HR 149	Duncraig Castle	Dübs	1902	LMS 14684	-		1940
HR 30	Dunvegan Castle	North British	1910	LMS 14685	-		1946
HR 35	Urquhart Castle	North British	1911	LMS 14686	-		1946
HR 26	Brahan Castle	North British	1913	LMS 14687			
HR 27	Thurso Castle	North British	1913	LMS 14688			1935
HR 28	Cluny Castle	North British	1913	LMS 14689	-		1944
HR 43	Dalcross Castle	North British	1913	LMS 14690	-		1947

Drummond 0-6-0T V class

HR 22	-	Lochgorm	1903	LMS 16380	-		1930
HR 23	-	Lochgorm	1903/4	LMS 16381	-		1932
HR 24	-	Lochgorm	1903/4	LMS 16382	-		1930

Drummond 0-4-0T W class

HR 25	Strathpeffer	Lochgorm	1905	LMS 15051	BR 55051	1965
HR 40	Gordon Lennox	Lochgorm	1905	LMS 15052	-	1930
HR 45	-	Lochgorm	1905	LMS 15053	BR 55053	1957
HR 46	-	Lochgorm	1906	LMS 15054	-	1945

Drummond 0-4-0 Large Bens

HR 61	Ben na Caillich (Renamed Ben na Caillach)	North British	1908	LMS 14417	-	1936
HR 63	Ben Mheadhoin	North British	1908	LMS 14418	-	1931
HR 66	Ben Mholach (Renumbered HR 64)	North British	1908	LMS 14419	-	1935
HR 68	Ben a'Chait (Renumbered HR 65)	North British	1908	LMS 14420	-	1934
HR 60	Ben Breac Mhor (Renamed Ben Bhreac 'Mhor)	North British	1909	LMS 14421	-	1932
HR 62	Ben a'Chaoruinn (Renamed Ben Achaoruinn and Ben a'Chaoruinn)	North British	1909	LMS 14422	-	1937

Drummond 0-6-0T X class

HR 39	-	North British	1909	LMS 15300	-	1936
HR 64	-	North British	1909	LMS 15301	-	1934
(Renumbered HR 66)						
HR 65	-	North British	1909	LMS 15302	-	1933
(Renumbered HR 68)						
HR 69	-	North British	1909	LMS 15303	-	1932
HR 29	-	North British	1911	LMS 15304	-	1932
(Renumbered HR 43)						
HR 31	-	North British	1911	LMS 15305	-	1934
HR 42	-	North British	1911	LMS 15307	-	1934

Frederick George Smith 1912–15

Smith 4-6-0 River class

HR 70	*River Ness*	Hawthorn Leslie	1915	LMS 14756	-	1939
HR 71	*River Spey*	Hawthorn Leslie	1915	LMS 14757	-	1936
(HR 72)	*River Tay*	Hawthorn Leslie	1915	LMS 14758	-	1945
(HR 73)	*River Findhorn*	Hawthorn Leslie	1915	LMS 14759	-	1939
(HR 74)	*River Garry*	Hawthorn Leslie	1915	LMS 14760	-	1946
(HR 75)	*River Tummel*	Hawthorn Leslie	1915	LMS 14761	-	1939

Christopher Cumming 1915–22

Cumming 4-4-0 Snaigow class

HR 73	*Snaigow*	Hawthorn Leslie	1916	LMS 14522	-	1936
HR 74	*Durn*	Hawthorn Leslie	1916	LMS 14523	-	1935

Cumming 4-6-0 Clan Goods

HR 75	-	Hawthorn Leslie	1918	LMS 17950	BR 57950	1950
HR 76	-	Hawthorn Leslie	1918	LMS 17951	BR 57951	1951
HR 77	-	Hawthorn Leslie	1918	LMS 17952	-	1946
HR 78	-	Hawthorn Leslie	1918	LMS 17953	BR 57953	1948
HR 79	-	Hawthorn Leslie	1918	LMS 17954	BR 57954	1952
HR 80	-	Hawthorn Leslie	1918	LMS 17955	BR 57955	1952
HR 81	-	Hawthorn Leslie	1918	LMS 17956	BR 57956	1952
HR 82	-	Hawthorn Leslie	1918	LMS 17957	BR 57957	1946

Cumming 4-6-0 Clan class

HR 49	*Clan Campbell*	Hawthorn Leslie	1919	LMS 14762	-	1947
HR 51	*Clan Fraser*	Hawthorn Leslie	1919	LMS 14763	-	1944
HR 52	*Clan Munro*	Hawthorn Leslie	1919	LMS 14764	BR 54764	1948
HR 53	*Clan Stewart*	Hawthorn Leslie	1919	LMS 14765	-	1945
HR 54	*Clan Chattan*	Hawthorn Leslie	1921	LMS 14766	-	1944
HR 55	*Clan Mackinnon*	Hawthorn Leslie	1921	LMS 14767	BR 54767	1950
HR 56	*Clan Mackenzie*	Hawthorn Leslie	1921	LMS 14768	-	1945
HR 57	*Clan Cameron*	Hawthorn Leslie	1921	LMS 14769	-	1943